ED HARDY

PUBLISHERS/EDITORS: V. Vale, Marian Wallace
COVER PHOTO & BOOK DESIGN: Marian Wallace

RE/Search copy editors, staff & consultants:

Kelsey Westphal
Andrew Bishop
Emily Dezurick-Badran
Robert Collison
Patrick Kwon
Cathryn Moothart

Whitney Ray
Penelope Rosemont
Gail Takamine
Gloria Kwan
Elizabeth Edwards
Maya Riebel

RE/Search Publications
20 Romolo Place #B
San Francisco, CA 94133
(415) 362-1465
info@researchpubs.com
www.researchpubs.com

TABLE OF CONTENTS

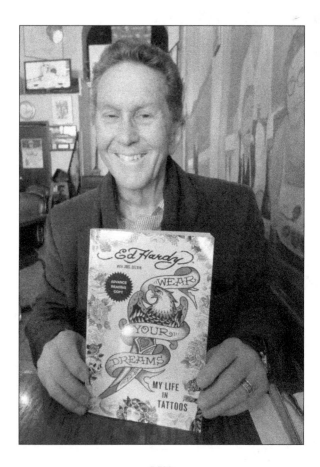

INTRODUCTION by V. Vale

Since the Sixties Ed Hardy has produced his art while raising the once-overlooked medium of tattoo to museum-level standards, producing archetypal, iconic, technically dazzling work reflecting the world history of visual art production. He studied printmaking at the San Francisco Art Institute, then turned down a graduate fellowship to Yale, electing instead to work for himself as a ground-breaking entrepreneurial tattoo artist. Along the way he inspired hundreds of artists to share in his mission: to imagine, invent, produce and keep perfecting work that provokes thought, admiration, and our favorite kind of question: "What does that mean?"

Today Ed Hardy has retired from tattooing. He's producing paintings, drawings, prints, ceramics, scrolls, installations, and more. His Hardy Marks imprint has published some thirty books, with more on the way. We hope this slim volume inspires readers to create art and follow their own path toward independence and multi-faceted originality.

—V. Vale, RE/Search founder

▌V. Vale: Welcome to *The Counter Culture Hour.* I'm your host, V. Vale; I've been doing counter-culture publishing since 1977. I started with *Search and Destroy,* which documented the Punk Rock Cultural Revolution, and in 1980 founded RE/Search.

Today we are extremely fortunate to welcome Ed Hardy. Ed was in the best-selling book that RE/Search ever published, *Modern Primitives,* and he was there because I personally considered him the world's greatest tattoo artist. But he is more than that—he's a historian, a philosopher, and has also blossomed into being, really, a painter. But he's also been counterculture

from Day One, as kind of a rebel surfer—really young. Then he was influenced by the Beat, Hippie and Punk Rock countercultures.

Ed Hardy has challenged the world in terms of tattoo quality, and has done hundreds of thousands of tattoos on the human body. *The Counter Culture Hour* focuses on the topics of art, creativity, independence—often there's a challenging of the status quo, cultural values and aesthetics.

Let's welcome Ed Hardy. Thank you for being here, Ed.

■ Ed Hardy: It's great to be here. Thank you for that congratulatory introduction, Vale. It's always fun to sit down with you and hash over our mutual perceptions of the world and our personal aesthetic quests.

I think we've both done a lot to change the world in ways that maybe some people are not aware of. Many people believe that what's happening at the time they're alive, or the kind of cultural swell that they're a part of, fell off the truck so to speak, and they don't understand that it actually has *precedent.* And that this idea of, for lack of a better word, Bohemianism, or countercultural, confrontational or subversive movements—*life* movements—has a terrific history.

I know you and I are both very interested in tracking and paying homage to that, and getting people to understand historical movements. So that's very fun.

■ V: I remember when I first went to your tattoo studio ages ago. I was amazed by this huge wall of art books. As a publisher I am very interested in art, and you had books that I didn't even know existed. This library you assembled was eye-opening. How did you happen to become this bibliophile?

■ EH: I think, as with many things in life, we are just *born* with that. You and I both have a passion for books and writing books. I tried to write the first history of tattooing when I was 11 years old; I was fascinated with the subject. This is documented most succinctly in the RE/Search *Modern Primitives* book that pretty much breaks down my crazy, checkered career.

I was very passionate about books and reading at a very early age, and I became completely hypnotized by tattoos. When I was 10 years old, I would hang out in tattoo shops, copying designs off the walls and putting colored pencil tattoos on friends. I remember having this urge to document the subject, and I would write about it on the school notebook paper with the blue lines.

I was frustrated that I wasn't old enough to do this right. Back then, it would've been 1956, and there would've been *three* books in English published on tattooing in the 20th century—one was a completely anthropological study from about 1912 or so.

Anyway, this led to my being obsessive about books and historical research... particularly historical *art research.* I had done this through my early art career before I began tattooing professionally, as I had gotten a degree in printmaking at the San Francisco Art Institute in the early Sixties. I collected as many art books as I was

Tattoo City inner sanctum

able to on the budget I had.

In 1982 I began to publish tattoo books and magazines before there were any tattooing magazines. RE/Search Typography was able to do all of the typesetting on those, and Leo Zulueta and I hand laid out this first-time tattoo book, *Tattootime,* that had a phenomenal effect on things. Books are crucial to me; they are still a huge part of my life. Of course today, people have this dour idea that books are all *over with.* This friend of mine, a younger tattoo artist who is actually a very bright guy and has a dual degree in art and literature, asked, "Why didn't you just publish this as an electronic thing?" and "Why do a book?" and I just refuse to believe this.

The physicality of books is still extremely important to me: the vibe, for lack of a better word, that you get from seeing a book. Historic books, like the ones we were looking at in your amazing stacks the other night, are just *treasures.* They become something legitimate in themselves, above and beyond what the things are that are within the book itself. I think great books are really important, and I'm always on the quest to find more.

▌ V: I'm really glad, Ed, that you haven't turned your back on books yet. Because it's tempting to

do that, what with all of the mainstream media propaganda. We're getting to the point where you can download a book and print it out at home, but it looks so ugly.

■ EH: It's like everything else in this—I don't

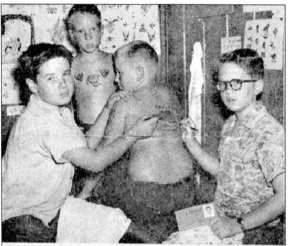

LITTLE MERCHANTS: A lively business of tattooing is the strictly private enterprise of Lenny Jones (left) age 11, of 818 Heliotrope Ave, Corona del Mar, and Don Hardy (right), also 11, of 703 Goldenrod Ave. Here they are working on one of their customers, Roger Johnson, 11, of 612 Goldenrod Ave., while another

Hwy, looks on. The tattoo artist parlor is set up in Don Hardy's den, and both of the little entrepreneurs have mighty official looking though home-made business licenses. They use colored pencils for their tattooing. Some of their business regulations are: "You must have permission of your parents" . . . "Ages 9 to 12"

News clipping showing Ed's (right) first tattooing business

know what the appropriate buzz words are for the world we live in—but this whole thing about the "information society." I think there's this

terrible flattening of everything, where—this is clichéd I know—it's all reduced to soundbites. It's all reduced to the idea that what matters is just the *facts* of the things coming through that you can download. But the stylistic component is important: the voice of the person doing it, the hand of the painter or the voice of the writer. It just pisses me off that **there is just so much trivialization of the aesthetic component**. If the medium is the message and if you get everything off of an electronic download, you're missing a hell of a lot that is important to our species.

▌ V: In fact aesthetics, period, are downgraded as much as possible. You're supposed to live in a modernist world where the only thing you go *"wow"* at aesthetically is this pristine, brushed aluminum surface, of an iPhone or whatever.

■ EH: It is of course, a complete creation on that end of the consumer economy. One of the things that made tattooing popular for *me,* was that it was a challenge. I thought tattooing was incredible. I didn't really have a fully formulated philosophy when I got into it and started tattooing in 1966, but I realized that it should be a *cultural option.* But it had sort of stinky baggage, because it was so transgressive to all of the religions that have controlled Western culture and people's

Tattoo City library

awareness of their bodies.

I'm always asked in interviews why tattooing got so popular. It's because people were being able to take back something that was completely theirs. No one should be able to tell them what to do with their bodies—tattooing is demonstrating a really primal kind of art imperative.

All the points you made in *Modern Primitives,* where people were using their bodies for all kinds of forms of expression, were something that was really desperately needed, 20 to 25 years ago, and it continues to be today. It will *always* continue to be that way, as the world gets

more and more controlled and more and more predicated on what very, very intelligent, crafty advertising people are doing where they are convincing you what you need. Like the newest electronic gadget—people's lives are just filled up with empty calories.

■ V: I couldn't agree more. We are inundated with so much media that *everything* ought to be perceived as advertising, including all the news programs on TV, and all the so-called "factual" articles in magazines, newspapers, television. It's all advertising for a certain point of view, an outlook. All the speeches by the President are just advertising. We live in a world where everything is advertising, and how do you fight that?

■ EH: I think that the only salvation from being completely crazy or just being so bitter about everything is... I just thought: I'm old and I'm not really bitter. I'm just pissed off about stuff. But I've also been able to function, thank god, very fortunately in an arena that's been *outside the system*. It is hooked up with what I like to call: **an "international network of weirdos."** I'm lucky to have this network of people with ideas, expressions and outlooks that are very important and *different*. They don't all listen to the same types of music, or just hang out with, say,

surfers. They're all idiosyncratic.

It's sort of a desperation and a determination to live your life—as corny as it sounds—to be *clear* of this crap. My biggest inspiration for this was reading *Burroughs*, because it just fit my sensibility: **I wanted to run an anonymous, non-threatening, exterior stylistic image, while being able to carry on a completely subversive mentality within.** To have that agenda, without raising a flag for all of the people who want to shoot you down for that, literally.

So you just have to carry on and keep in touch with those people who are still determined to do this, because it will never be completely lost. But the world's in worse shape than it's ever been, and it's partly because of the sophistication of information and communication technology. The "bad guys" have all this access to everybody, and the tools of advertising, and ways of promoting their agenda in very *subtle* ways.

I've been reading about Chinese art history and classical Chinese paintings… about these dynasties where the poets and the painters would literally go into the mountains and disappear with a network of friends, because they were living in a terrible situation… and that heartens me to think about. I find great comfort

in knowing that creative people, or alternative-aesthetic people, go on throughout history, and figure out ways to *survive.* You're never going to change history or the status quo of meatheads who are making the world miserable, but you can certainly keep a thread of *dissent* going.

■ V: One of my goals is to construct for myself *a history of cultural dissent*—find inspiration from history as much as possible. Yet we're in an *Eternal Prison of the Now*, where the latest electronic signals hypnotize you and keep you distracted—it's 24/7 Distraction Culture.

We're living in an *ahistorical* time: kids growing up don't even know who Eisenhower is, the American President in the Fifties. I can't even conceive of what it's like for kids growing up today—what with the deteriorated state of public education. The *San Francisco Chronicle* asked a couple of high school students what the Fourth of July stood for, and one of them said, "Is it when Vietnam ended?" It was like a *Monty Python* skit—but it's real.

■ EH: It's been fantastic, though, to be able to witness what we've lived through. I think that, again, we are very fortunate to have the kind of fluidity and the range of our interests. We could go through what *you've* documented, what

you've seen, what you've been able to have participated in and then *influence* by documenting it and being not only the all-seeing eye but one of the people *working* in it.

Transcending any kind of category, like what you said in your introduction about me: I've never fit in *one* category. If there is a category, it's just that I was fortunate to be a California guy *and* open to a lot of particular energy that I think is inherent and possible to utilize in this

Tattoo City: Mary Joy

state (and others up against the Pacific ocean). A lot of things that happen here don't happen

in the rest of the country, or in Europe. But it's great to move through all this and find a *common thread:* being able to relate to people in different environments, whether it's Punk or the Beats, or anything.

▌ V: Well, you've even lived in Japan and have some kind of working knowledge of Japanese. How did you become interested in Japanese culture and cultural history?

■ EH: Actually, for a three-minute psychology "thing," my father got a job with the MacArthur occupation. He was an engineer, and when I was six he went to Japan. He was a real Soldier of Fortune—not with weapons, but with going all over the world for jobs, and he completely fell in love with Japan. When my mother figured out he wasn't coming back, she divorced him, and so I have this thing about Japan. It's very simple: *that's where dad went.*

He would send back all of these cool things, like those jackets that servicemen wore in the Fifties with dragons and tigers on them—the reversible satin jackets. So I had an early interest in Japan. Then I was interested in Zen, because the first "Beat" coffee houses opened up in my little Orange County area in '57 and '58: one in Laguna Beach and one in Newport. I bought my

first copy of *Howl,* which of course was a *bomb* at the period, and I became very interested in the Beats and Zen.

L to R: Doug Hardy, Ed Hardy, Mary Joy, Aleph Omega in front of flash wall at Tattoo City

When I went to art school, I became very interested in *Zen aesthetics,* although not in a visually-identifiable way in the art I was doing. My mentor, Gordon Cook, who taught me to etch at the San Francisco Art Institute, had a very sophisticated component of Asian aesthetics in his art outlook, so that became *my* thing. Then, when I re-ignited my interest in tattooing after being obsessed with it for three years from the ages of 10 to 13, it was *via* seeing a book of classical Japanese tattooing—that was what made me want to get into tattooing. I followed the Japanese "thing" really, really strongly, and was able to move over there in 1973... where I lived and worked with a classical Japanese tattoo master. I was the *first* non-Asian to ever do that, so it was a big deal.

▌ V: What was his name?

■ EH: Kazuo Oguri; his tattoo name was Horihide. He had been corresponding with a lot of tattoo artists in the West and had a translator for his letters. Sailor Jerry Collins in Honolulu introduced us via the mail, and I was really obsessed with the Japanese tattoo. After about six months, I went back to the 'States, and then I opened my *private* studio on Van Ness Avenue near Union Street in 1974. So the Japanese

"thing" has been a really big part of my outlook…
and of course, the Chinese aesthetic and the flavor
of Japanese history.

■ V: But I wouldn't call you a Buddhist because I
think you're more active—you're an artist *first*.

■ EH: Well, yeah, I don't let any labels stick to
me. I really appreciate a lot of Buddhist philoso-
phy. The essence of it to me is more of a *philoso-
phy* and less of a religion. Just: whatever works,
whatever seems to feed in and enhance your out-
look or understanding of the world, and *why* we
are doing the work we do… that's good for me.

■ V: Well, speaking of the work you do: how
many tattoos have you done, or how many peo-
ple have you tattooed—do you know?

■ EH: No, I don't know. In my early years I
was tattooing military guys—that was mainly
who got tattooed in those days. In the Sixties it
was mostly tattoo shops around military bases.
I worked in San Diego for four years and Seat-
tle and Vancouver, B.C. before that, so in those
years I probably tattooed thousands of people,
because it was all *small* tattoos. Then, when I
really got rolling with this *Japanese* idea and
opened the studio here in San Francisco, the aim
was to *liberate* the medium. To make it a *com-
missioned* experience where people would come

in and give you the idea and then I would draw it up. So in doing these more *epic* tattoos, there weren't as many numerically warm bodies walking through the door, but maybe I'd spend one hundred hours over a few years tattooing these huge scenes on them. I don't *know* how many tattoos I've done...*a lot.*

■ V: Must've been thousands.

■ EH: Yeah, it was thousands—tens of thousands of people. There's a line in one of my favorite Neil Young songs where he says, "I need a lot of people, but I can't face them day to day." Sometimes I sort of burn out and don't want to have to hear another life story, but I *am* addicted to it and—you get addicted to the *human contact.* One of the *prerequisites* to be successful as a tattooer is: you have to be able to talk to people, and relate to them, to a certain degree.

■ V: Do you have to be an amateur psychoanalyst?

■ EH: Of course! In fact, sometimes things would get so *over the edge* that you'd think, "I should really be paid extra for this." To hear these really heartbreaking, and/or ridiculous or repulsive or amazing stories... it really is cool.

And of course I've thought, "Gee, if I could have a tape recorder running, capturing some of

these things!" Occasionally I make notes about some of the stories and weird occurrences of *synchronicity* when I was tattooing somebody and what they were saying. It's been a fantastic business for me, and has given me a great life, and I've always realized that it is a *business*.

Of course, it's an art form; it's a *medium*. But because it takes *another person* to make it real, unlike something you do solo (like painting or drawing, or whatever), it is a commercial enterprise, and it went really well for me. I got to do a lot of self-expressive things with it—*not* to develop an agenda, because I wanted it to be *right* for the person wearing it.

About 20 years ago I made a move to Honolulu because I'd started surfing again—I wasn't tattooing full-time for the first time. Previously, I had put 20 years into *just tattooing,* where I did no art for myself. So I started painting and drawing again… *Therapy Art,* where I could just do what *I* wanted—I didn't have to pass it by somebody and see if that was right for *them.* And if it got screwed up, I could tear up the piece of paper. So that's been my main focus for the last 20 years or so.

▌ V: You know, I was trying to imagine a life for you if you'd just been a painter. Well, in a sense

you *have* been a painter—it's just been on a different medium.

■ EH: Tattooing was a great challenge, too. The key thing that I loved about it when I got into it was the *freedom*. Gordon Cook, my mentor at the S.F. Art Institute, kept hammering at me to *get out of the academic thing*. I'd gotten a full fellowship, having been accepted to Yale—I was going to go to a hotshot university for my Masters degree, and I would've ended up teaching printmaking. I was terrified about it at the time—I wasn't sure it was going to be *right* for me.

And I found tattooing again. I got into it because I was interested in what I thought it was: *a forgotten American folk art.* And then I realized how it could *open up*—I met my initial tattoo mentor in Oakland, the incredible Sam Steward. Incidentally, there is a kind of overarching book written right now on his life by Justin Spring: *Dear Sammy.* He's done other biographies on important American visual artists, and he interviewed me at length over the last couple of years.

Sammy Steward had a tattoo shop in Oakland, and he was the first renegade intellectual I'd encountered. He'd been a professor of English literature and he'd fled academia and went into tattooing to distance himself from academia.

Anyway, Sam Steward, who tattooed under the name Phil Sparrow, was part of Gertrude Stein's circle. He was in constant communication with Alice B. Toklas until she died. He'd been to France prior to WWII as a young author, and he was a prolific author of gay porn. His books were published in Denmark and illustrated by Tom of Finland. So he had this checkered career of operating in lots of different realms. He was also a confidant and sex partner of Kinsey—he participated in all the Kinsey experiments. He didn't tell me this right up front—he was still in the closet when I met him, although it didn't matter to any of *us,* and it was evident in the way he ran his shop.

He was so different from all, if not most, of the tattooers at the time... and he was a literate guy. After meeting him and hanging out there a bit, I thought, "Wow, maybe you could get into this business and make a living in an independent fashion, and still keep your mind intact and grow intellectually, and not be part of a larger conglomerate."

I was working at the Post Office to support myself and my wife and infant son and to finish up art school. I just didn't want to be part of any big machinery. So yeah, I did my art. I think if I

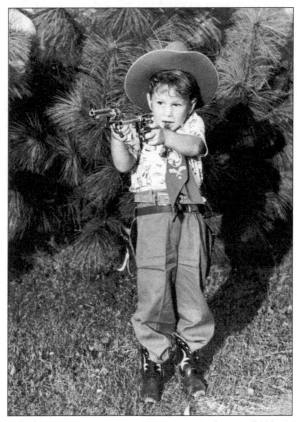

A young Ed Hardy

were to be a painter or had worked in any other medium, I would've had to either work a job that didn't interfere at all with my creative side, or link it up to teaching—which is what most of my friends from art school did. Even ones that are incredibly successful today with their own art don't make a living out of it—they are still caught in an academic "thing." I know there are pluses to it, but I sure hear a lot of complaints from those guys about being trapped *between* the administration and the students.

■ V: You have to deal with *hierarchy,* and who wants to deal with that? And you have to deal with the faculty lunches and the dinners and that's where a lot of the important decisions get made. As an advocate of counterculture in general, I say: **Avoid hierarchy as much as possible**. It's almost a principle.

■ EH: That sums it up exactly.

■ V: I like to work with people, I like to collaborate with people in a complementary way. But still I prefer being alone at home the most.

■ EH: That's the best! Hell is Other People, right?! [Sartre *No Exit* reference]

■ V: Well, there is a side of me that enjoys seeing certain people, such as yourself.

■ EH: There's the balance. But the key, the

crucial thing is that *you don't have to go out if you don't want to.* If I find myself in the middle of an uncomfortable event like a poetry reading or a literary event, I think, "Well, I didn't have to come to this!" Francesca and I grind our teeth about the crap you run into when you're self-employed, but essentially it's far better than the alternative. I just remind myself that *this isn't so bad.*

∎ V: I called you a philosopher, but I don't think philosophy should be high-falutin'—I think it should be practical. I was very impressed by what you said years ago: "With the time left to me in life, I'm not going to read that much about politics and news, but focus on *art history.*" However, whether we want to or not, we still hear about the latest atrocities in the news...

∎ EH: You can't escape it. Actually, I've never read that much political stuff—I'm kind of an *idiot savant,* I guess. Art's my category and then I link up other parts of the world to that—it's what I understand and have tremendous empathy for and facility with.

Somebody said decades ago: **All things personal really are political**. The way you run your life: *that's* how you impact things. If you can impact things on a one-to-one basis with people,

or with something you've written or published—something you've gone public with… Attitudes and ideals are important. That's great, that's important, that's enough.

I don't read mainstream news—I get too furious; it's insane! I'm not going to waste time on that. And yes, I want to read art history. I mean, last night I was in heaven. I started getting a cold, but I just sat down with a collection of later period Chinese calligraphy and was reading the text and suddenly I realized how insanely happy I was. That **this is the ultimate luxury: to just read,** pursue some kind of scholarship, with no end in mind; just absorbing the material and somehow knowing that it's *enriching* you.

I dislike that whole elitist egghead camp, and I think I've sought out or have become magnetized toward that *renegade intellectual type.* People that have a lot of smarts, who've had a lot of accomplishments and who have basically a blue-collar outlook. That's what Cook was about. Sam Steward was very pragmatic, along with the tattooers I knew—that helped me a lot. A few of them were actually great intellects and they were total counterculture guys down in sailortown. Yet no one would ever recognize them as anything special.

So, I just try to *avoid pretense if at all possible.* I

know that I can tend to sway into making the pretentious statement, but... Too many people in the world are set up as know-it-all great authorities, but they don't really have the chops to *deserve* the accolades they get. Again, the Burroughsian way is a good approach, from my particular taste.

■ V: One of my favorite quotes was from Marx— Groucho, that is: "I wouldn't join any club that would have me as a member."

■ EH: That's exactly right.

Bert Grimm's shop in the mid-Fifties

■ V: Yet, at the same time, I wish that sometimes we could all be in one huge room. A lot of the people I've interviewed are trying to be independent artists—who are often some of the most interesting people in the world. For one thing, they have an outlet for everything, so they're less likely to be "screwed up."

■ EH: I'll go out with Francesca and meet people and have this tremendous input and great experience and rapport on some level, whether it's with humor, or intellect… and that's great. I just feel guilty because I don't keep up with the people—this massive *network* that I've accumulated over all these years. But I don't want to do a blog or anything like that. I just try to see people in person when I can, and email or phone-call when I can.

■ V: I've said that *what's lacking most in people's lives is interiority.* You know, shutting off all of the electronic media and just being by yourself—maybe you and a journal in a room alone for an hour. Or there's your laptop, but then there's the distraction of the Internet, which can be deadly.

It wasn't so long ago when the resurgence of tattooing was considered post-modernly avant-garde: *this is new and hot.*

■ EH: People feel that what they're in the midst

of is new to them—it lights them up. But it is important for them to realize that there are *precedents*. **How many original thoughts are there in the world? Not too many!** We're just recycling things that other members of our species have come up with at some point in our history, and applying it to the contemporary situation.

I get approached by different media people who'll talk about "tattooing's current wave of popularity" and ask me the same six questions. I'll say, *"This has really been documented."* I'll turn down a lot of interviews because they don't do their homework. It's all over these TV shows, reality shows and that stuff... which is fine.

People should be excited about it if they're going to put a mark on themselves... and it *is* a thrilling, liberating thing to do. It is a feeling of power... of going to the brink, a rite of passage, and all that. It does hit those certain synapses in us that go back to way before recorded time, I'm sure.

I guess it'll keep going... it'll keep rolling on at the insane level that it is. The latest twist in my very weird life was this whole fashion thing that fell on my head—that a lot of people in the tattoo world are really miffed about. They think it insults the pristine integrity of tattooing.

I got involved in some shirt designs with some very cool guys, one Japanese and one from L.A., a couple of years ago. Some of the garments that they were putting my images on, got the attention of a fashion designer in L.A. named Christian Audigier. He had created a huge buzz with his Von Dutch line (which is a whole other story) based on the work of a really alternative irascible painter and car pinstriper from the Thirties and Forties. There's a brand new book out about Von Dutch by Pat Ganahl who took a lot of the photographs that were used. It was the first really thorough book on Von Dutch's career: *Von Dutch: The Art, The Myth, The Legend*. Talk about a loner and a free agent!

This guy Christian Audigier was a marketing genius and he had just gotten tired of the Von Dutch line and had dropped it. In Los Angeles he saw a shirt with one of my images on it and went after it like the proverbial shark after a bleeding lamb. He said, "Who is this Ed Hardy? I have to have this!"

So he's started this insane fashion franchise on a global level. There is an energy drink and everything. He created it mainly using images that I painted for sailors and marines 35 or 40 years ago. It's crazy to see all this stuff.

They branded me with this signature, "Ed Hardy." It's a complete *construct*—it is part of the world of Hollywood *bling* and it's like going to the moon for me to see it. It's bizarre. It's like **people can have the tattoos but they don't have to be tattooed**. I just think it's hilarious and completely mind-blowing. Very strange.

Tattooing seems to still pack a wallop as something that is confrontational, or Outsider, or whatever, no matter how popular it gets. At the base it means: you get the tattoo, and it is there, essentially forever. And more power to it, because at the time that *I* got into it, it was the most transgressive medium that I knew about.

■ V: See, you were really being a rebel then—

■ EH: Against High Art, when Conceptualism and Minimalism were really beginning to hold sway. Of course, any "fine art" was co-opted into, well, a business. Again, I love tattooing for that aspect: it's a sort of "Freedom Road" in many ways.

■ V: Well, it's a hard road when your art starts getting popular. Commercial potential starts being developed and other "artists" (or whatever they are), start questioning your integrity. Yet you really didn't do anything—these *other people* did. They did all the marketing, they're the ones

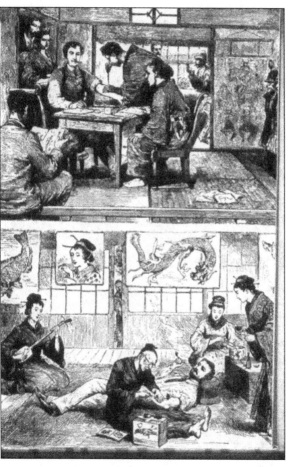

Depictions of *gaijin* (non-native visitors to Japan) receiving tattoos

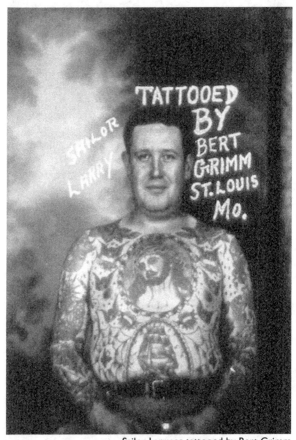

Sailor Larry as tattooed by Bert Grimm

that manufactured the shirts, and they're the ones that started all this hype about you.

■ EH: And to me it just gets down to… what if there *were* something—I can't even think of an image that would be too pure, or too holy or has too much integrity that it should *not* be on 5 million t-shirts?! This is tattooing, these are designs made for sailors and marines. This isn't stuff that I have any great investment in.

For that matter, what if someone wanted to pick up some of my paintings which are too "off in a different realm"? I guess you could manipulate those into fabric or something—I wouldn't even care so much about *that,* as long as it was done with some humor and was well-produced. Because again, I'm anti-"Elitist Art."

One of the things I liked so much about being a printmaker was this *democracy* where you could have a multiple original. We were talking the other day about Warhol, and you were very succinct as usual about Warhol's importance and his extreme precocity of vision of what would happen with the world, and the way things would go. He had this whole idea about making *multiples* and making things that were so-called "commercial" and popular, which incidentally *exploded.*

Right when I started getting serious about art, I was in a perfect position historically, and geographically. I was in Southern California. I got really serious about gallery and museum art around 1960 or '61. The Pop Art movement was happening—I saw all the shows that Warhol and Lichtenstein did, and in L.A. those ideas were thriving.

▌ V: How did you first learn tattooing *technique?* You once told me you learned "stuff" from Zeke Owen, whom I met long ago at a party at Lyle Tuttle's old tattoo shop on 7th Street, S.F.

■ EH: In the tattoo trade, people *would* be very "close to the chest" about secrets. It could be very hard to get into tattooing; it was a closed shop. It was kind of like a medieval guild, and you'd have to be "tested" to see if this grouchy old fart would tell you something about *how to mix your ink.*

People who realized you had a lot going for you (within reason), and weren't going to take away their business, would share knowledge with you. All the old stories and hippie sayings *(what goes around comes around):* they'd let *some* of that stuff out, as long as it permeated and enhanced your life. You help other people and then they help you back. That's what it's all about.

■ V: In theory, that's what a counterculture does. For a brief minute in time, your relationships are not capitalist relationships, there isn't a profit motive involved. It's more on the level of friendship or *mutual aid,* which is the basic principle of anarchy. With Mutual Aid you *both* have to benefit by what's going on.

I personally am wondering how you could even create a counterculture in the future… if it's even possible. Because it's a *group activity.* The last one I experienced was Punk Rock, which was amazing. No one was making any money, everyone was being wildly creative, you had some of the wildest conversations, very black humor, funny. And you stayed up all night, that's the thing that I liked. I mean, *who wants to be part of a society where you just go to bed early for all of your life.* Yet there were hazards in that lifestyle, too…

■ EH: Of course there were a lot of them that didn't make it through. But hopefully as you get older, you can become aware of what is really important—about the components about it that really count, and the components that are just *peripheral* to the primary thrust of your goal or your mission. You figure out ways to have it go forward in the best possible way, and make the best changes. And sometimes people get stuck in

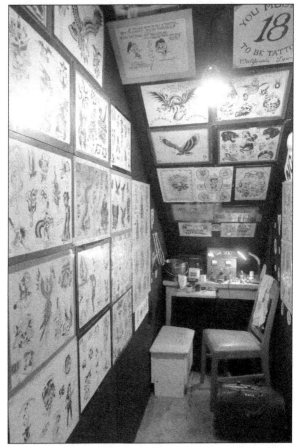

Tattoo shop installation at Ed Hardy show, Ft. Mason

the *peripheral*, in their drug habit or whatever it is, and cave in to whatever fashion or attitudes seem to be prevailing.

I think it's extremely hard for people, as they age, to remain flexible… to keep a fluidity, a purpose, and an awareness of things. It's very hard to keep that going, but what gives me hope too, is to look at the *resonance* of the kinds of things that have gone on before. I do feel that today there is no identifiable movement or thing that is as exciting, or is nearly as exciting, as Punk—everything is recycled. You'll see groups of people, you recognize them and their style and think, *Wait a minute, this is 2013 but this is a 1976 style.* Older things are still relevant to people. They'll find a part of our history and they'll go, "Yeah, it speaks to me," whether it's skate culture, Punk Rock, skinhead, or whatever it is.

It's interesting: the simultaneity of cultural options today. It's the first thing that knocked me out the first time I went to England in 1979. I loved seeing the kind of ferocious devotion that people had to their "tribe." You'd see these middle-aged Teds, these guys with the velvet drapes that they'd stuck to since they were young hell-raisers, and I thought, "That's terrific." The English are much more kind of loyal

to their "thing." The skinheads were doing this; it was pretty neat. England's such a fantastic cultural ground.

■ V: Early on I was interested in the skinheads; originally they weren't racist.

■ EH: The original skinheads were not racist. I have a really good friend in London who was an original "skin"; then he was a Mod—he was just a really great London guy. He gave me all this insight into how it *really* was, and the music they would listen to. Music was a huge component: ska and all that.

■ V: I'm sure that as a tattoo artist you've probably been criticized (on a certain level) for dealing with too much surface and not enough depth. You must've gotten this kind of academic reproach from *somebody*—

■ EH: I think tattooing is hard for people to get a grasp of. People would get interested in it because they would see it as this interesting "primitive" action. When I started, people in the High Art world started sniffing around, and I became involved in some gallery shows of art work that weren't necessarily just tattoo flash (*design sheets*), but maybe it was work by tattooers who worked in other mediums. They were all completely conscious of themselves as *artists* and we

were going to have this group show in Chicago: Dan Higgs, myself, Manuel Ocampo and a couple of other people.

Dan said we should call our show "Retarded Hillbillies" because this was right at the beginning of the early Nineties, when "Outsider Art" began getting a lot of buzz. Now, of course, we know it goes all the way back to Dubuffet's prescient involvement… and the awareness of how important and powerful all that kind of art *is:* the art of institutionalized people—the so-called "insane."

Of course, the gallery owner didn't think it was funny at all, and would've never let us use that title. It's like they think, "Oh, here are some interesting primitives." Some people get thrown off when they see that: "What do you mean? You have a *fine arts degree,* and probably know more about historical art context (not just tattooing, but other fields) than what that particular person in power in that institution has read!" They don't like that.

Then there is the kind of snobbery in the art world where they would either be *for it,* because they liked the fact that it was somehow "innocent" and seemed "primitive," or they were *against* it because they thought that "that was all

it was." But nobody understands the *nuances* of the whole tattoo phenomenon.

I think eventually, because I'm still publishing (I've published over 20 books on tattooing)... someday... I've toyed with the idea that I should really write down, *for the record,* some of the legitimate realities of everything to do with tattoo. From having the tattoo shop as a *performance space*... the kind of physical space, with all these things that take considerations, all of these things that I'm highly aware of. And that are *true,* not notions I cooked up just sitting around the faculty lounge. I *did* this stuff. I've gotten flack from different sides but actually that's part of the *fun,* because ultimately it's like "I can walk out of here, pal and *you* can't"—when you're faced with those kind of people that are part of that academic infrastructure.

▌ V: It *is* an establishment and in it you are *established*—you can't leave it.

■ EH: Yeah, exactly. You know, I've taken a lot of classes and I like it. I have tremendous respect for all the people who teach, but I dislike when you get that involved where you have to ask, "Do I have to *defend* myself, or *explain* myself to you?" I don't think so. I am very confident in what I've done.

▌ V: "Surface vs. Depth" is one of the big issues being debated in the academic art world (or at least it was 10 years ago). But I read a recent argument that, on the contrary, there isn't enough *deep examination of surfaces,* because if there were, we would've seen all of these real-life "surface atrocity photos" from the wars in the Middle East which are *censored* from us—but they show them in European media. That's just an example whereby we aren't even given *the truth about the surface.* And we're kind of after truth in some weird way. We're not given enough *authentic* surface images!

■ EH: That's *it*: the censoring of everything is huge. And in terms of the visual arts (or whatever), I do read some art history and some cultural "analysis." I don't read a whole lot of analytical discourse, especially when the postmodernist thing hit. I can't *keep up* with most of it. And I'm not being willfully naive or stupid, I just can't *handle* it.

When these articles talk about "surface," what comes to my mind is that idea of a hardcore, hard-line stance that came with the heyday of Abstract Expressionism, where everything is **"What you see is what you get."** That's all it is. It's not *about* anything. That whole struggle

about telling stories, representation and narrative in art—as opposed to just full-on expression: "Here's this thing I'm making, and it's hitting you on some level that you can't really *talk* about." If you could *talk* about it, then you wouldn't need to make a picture!

I'm currently wrestling with that big time, because my work has gotten a lot more abstract in the last couple of years. Even in my school days when I was hit with some of the New York painters—Franz Kline and De Kooning and those

R to L: Ed Hardy, Laurie Steelink, Richard Shaw and friends

people—I was *wowed* by them. I really liked what they were doing, and almost felt *guilty* because I had this enormous social consciousness and was attracted by the idea that **Art should save the world and be for the masses.** But in recent years I've gotten to read more of that discourse of very heated philosophical discussions, because essentially that's what art history is: aesthetics and reading about philosophy. I find that really interesting. And it ties in with my studies of classical Chinese painting.

I looked at Chinese landscapes and thought, "Yeah, well they're landscapes—that's cool." Then I begin understanding that, and the essence of *calligraphy,* which is the highest form of art in China, Asia and Japan. And it's, of course, in one sense, the most abstract, while the characters are concrete concepts, but the way they're laid down is *abstract.* If I try to talk about these concepts I get a nose bleed!

I'm very interested in surface, content and the depth of things. The main thing is: *people need to think more.* They need to not be passive. What little I remember when I read McLuhan in the early Sixties about "hot" and "cool" media, was about being passive. You're sitting there and it's all coming at you, and there's not that *interaction.*

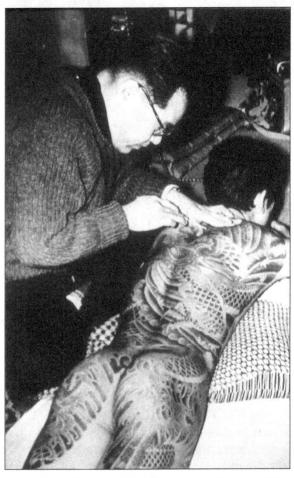

Kazuo Oguri (Horihide) tattooing an anonymous subject

One good thing about this Internet stuff is that there *is* that potential. With all that email, you are interacting; you are *putting in* something. You're not just letting everything wash over you.

▌ V: I know musicians who "rehearse" future concerts and even begin to write music together on the Internet. But it seems much easier to meet in person if you're collaborating on songwriting. A lot of people have "meetings" on Skype, but I find it too creepy; too theatrical. The old-fashioned telephone is better for complicated conversations and planning sessions.

■ EH: I have a cellphone and do email.

▌ V: Whatever works. I mean, **how many people can you collaborate with?** Like Burroughs collaborating with Gysin. Beyond that, you start to get into a hierarchy. Yeah, we live in very interesting times. One thing I love about the Internet is: all those books it used to take me decades to find—if you have enough money, you can find them *instantly*. It's so scary.

■ EH: In fact, there's one title… which I will not mention. Previously, I had called some bookstores, but… Then I looked on one search engine and it was exactly where you told me it would be. Of course, it's expensive, but they *had* it: multiple copies in varying places and with various

step-ladders of dollar signs. I feel sorry for all the small bookstores, and it's really sad they're going away—again, there's that [*death of*] *physicality*. Because there's nothing like walking into a musty bookstore and going, "Whoa—there it is!" Something you never knew you needed...

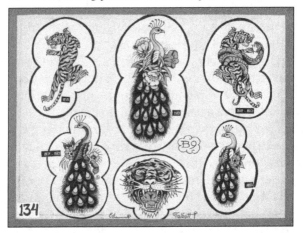

A set of Ed Talbot's tiger-themed designs

■ V: What I loved about the physical bookstore is that you could find things you could never have found on the Internet. Because you're in front of a shelf, and you're not pinpointing your selection. You're looking at the "New Arrivals." Everything is glommed together, and suddenly something

leaps out at you. You would never have checked the business section, normally, but lo and behold there's an *interesting book.*

■ EH: It's about opening your self up to things and letting things *happen.* Not being in control, being able to let some of that control slip. Whereas when you're looking on the Internet…you're not going to be surprised as much.

▌V: So Ed, how come on the level of shall we say, financial security, you're not like other counter-culture people. You've got it together; you actually own a house. How did that happen? Was that sheer luck, or did you have some fortuitous childhood training, or what?

■ EH: **Luck is where preparation meets opportunity.** That's my favorite refrigerator magnet slogan! For me, I think it's just because I worked really hard, and because I was in a business where you could make a decent living. My buddy Mike Malone once said, "When we got in this racket, it was like we thought this was really *living large."* Then you compare it to some people who are working in some big corporation and realize that there was actual real big money in that… but *we were free to do what we wanted to do.*

I inherited the house I grew up in, because

my mother died when I was quite young and her house was paid off. And despite my ideas of just partying the money away, my wife Francesca (who has a lot more sense financially than I do) said, "No, we should try to get a house." It was 1976 in San Francisco and things were not impossible if you had a starter sum, and we just worked from there.

So I never would have done it; I never would have saved up the money for a down payment. I came from a really standard, lower-middle-class upbringing. After my father left us—well, he'd saved up some money. My mother essentially worked in a factory. And—I'll never forget—she talked bitterly about: while she did the identical work that the men in the factory did, she was getting paid half. She was getting $1.10 an hour when the men were getting $2.10.

So I became very aware that what you did in life *mattered*. I kept thinking: **the only thing that I can do, and really love to do, is draw**—besides going to the beach—and you can't get paid for that!

I worked enough sh*t jobs. Then I thought, "I'm not gonna take this abuse. I'm not going to work in an environment where I will continue to be belittled every day and be miserable. So how can I make money with my art?" I was scheming

ways to make money with my art. And frankly, when I hit on tattooing—again, I was going to go to grad school at Yale. I could've gotten a *teaching job,* but thank god, the danger signs were up.

I got to know Phil Sparrow when I was hanging out in his shop a bit. I got a few small tattoos, and finally I said, "Well, can you *really* make a living at this?" Because all of the tattooers *at that time* were very, very adept at presenting themselves as just bums—a lot of them *were* bums. I figured that they all drove cabs at night (or something) and just had a tattoo shop because it was kind of *cool.* But Sparrow said, "Well, in Chicago when business was really good, I was making $12,000 dollars a year"—and this was in 1966. I thought, "I could support my family on *that.*"

He probably told me half of what he *really* made, because he had a Swiss bank account at that time! So that tipped it. Because I wanted to *develop* tattoo as a medium, I thought, "If this is a medium that is aesthetically challenging, creatively challenging, and I can get *paid* to do it, *that's IT!*" There was no question in my mind. So it didn't bother me at all to think, "Oh, this is *commercial art.*" It *is* commercial, but on the other hand there are all these other aspects of it that are challenging and incredibly rewarding.

I kept working hard for years. It wasn't like, "I want to make a lot of money tattooing," I just wanted to do a lot of tattoos. And as I kept busting my butt more and more with it, I realized I should be compensated "right," and get the prices up. When it was a *big deal* for the people getting them, they should realize that if they would pay money for something nice in their house or their car, then they should pay for *this*.

■ V: I'm sure that's a whole other discussion, on the art of maximally pricing your art work.

■ EH: Again, it's difficult in a lot of ways, because you're in charge. I began showing my art at galleries on La Cienega Street in Los Angeles when I was 17. I found an old piece of paperwork from 1962, and in those days the galleries took 25 percent (maybe 30 percent). Then it ramped up to the galleries taking 50 percent. If they're really doing their work for it, then that's fine, but then you become a *product*. You become a *component* of what they're presenting.

Another mentor of mine, JOAN BROWN, was a great painter, a great eccentric individual from San Francisco. She had a huge career going, she came out of the gate really fast when she was a teenager and got written up in *Vogue* (or something like that). She was a very striking young

Self-portrait of the artist throwing up, etching, 1964

woman, beautiful, and had these great really ballsy paintings. She was the first person from the Bay Area to get picked up by a big New York dealer—this was in the late Fifties. Then in the late Sixties she began changing what her paintings looked like, and the dealer said, "That's not so good, because these aren't really selling well." She went, "Screw you, I'm painting for myself," and they dropped her—she dropped the gallery, essentially. Again, here's **the integrity of doing what you want to do** (if you're lucky enough to find a dealer who understands you, and promotes you). I've had some good luck; the Track 16 Gallery in Santa Monica has been terrific for me.

▌V: Oh, they've actually sold stuff.

■ EH: Yeah, which is great. But if you go into it thinking, "I'm gonna do this to sell," then *that's* "commercial." It's about thinking, "Am I writing this because it's what I really believe? Or am I writing this because maybe somebody will buy it?" I think everybody struggles with that.

▌V: I think so. I mean, you have to survive, but you kind of want to be an *auteur* and have 100% control, despite whether everyone likes it or not.

■ EH: But it's very naive of people who beat their chests and gnash their teeth about *how nobody appreciates what they're doing*—nobody's telling

you to make art or write books! Essentially, in our culture, that's the most useless thing there is! So if you're going to do it, you have to be set to *just do it.* Just work at the soup kitchen or pump gas… or if you have to go into a corporate job,

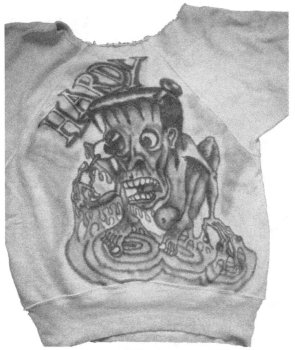

Ed Hardy sweatshirt design from 1958

then see if you can keep your intellect and *drive* intact—if that doesn't leach it out of you. That was our huge discussion in art school. Because in those days, nobody was really making money selling their art—none of the people that we really knew—our teachers, or anybody.

Father and son: Ed and Doug Hardy at Tattoo City, S.F.

We wondered, "Should you get a job teaching? And would that take away less of your so-called *creative energy* than a job in a totally non-related field—a *civilian* job that would not be attached to your art at all?" I think it's a dilemma for

everybody. But **the world doesn't owe you a living!** Just because you feel rhapsodic about what you've created... well, kids can play with their own sh*t. That's pretty basic; you shouldn't get upset if somebody doesn't recognize your genius. I've heard way too much of that.

■ V: As an artist, you've had a huge influence on a lot of humans actually realizing their identity. A lot of these people who have gotten tattoos are essentially broadcasting, in some way, that they've embraced a kind of counterculture that's *against a status quo aesthetic* and mode of thinking. Maybe, even, against political thinking that's conservative. And yet, you're kind of an outsider, too, even though you've had a huge influence.

I think **anyone who does a lot of work has to have solitude**... at least periodically.

■ EH: Personally, *that's* my biggest thing, and I'm the one responsible for it. I'm always boohooing that I don't have enough time to get into the studio... but then when I *am* in the studio I am in one of those states of mind which is (not to sound too corny)... you've gotta be in that *trance state*. You have to be *completely into the solitude.* You have to be focused, with whatever it takes, to trigger or allow those things to *flow out of you.* You have to have that.

Maybe *some* people can create among other people, *in public*. I don't really understand the whole thing with music, but obviously there are people making live music who are reaching some kind of *levels* performing... so that it's a *collaboration*. While working the ideas out, then the *real stuff* comes through. **You have to be alone, you have to cut yourself off from all distraction and the static** of whatever else is in this society we're living in. It's very hard today; everything is so seductive. You could be doing email and then you say, "Ooh, I'll look up this on the web," and suddenly you've lost yourself and an hour has gone by.

▌ V: Recently someone begged me to tell the future of what would be trendy in the future, because they thought I had predicted a lot of trends in the past. And I was thinking about tattooing, like: What is the future of tattooing? I just happened to spot this *New York Times* article about people who have been influenced by tattooing and body piercing since our *Modern Primitives* book came out. They're taking the next step of getting these little implants under their skin that can literally unlock their car door, their house door, or unlock their laptop computer.

■ EH: That's kind of out of the realm of *my*

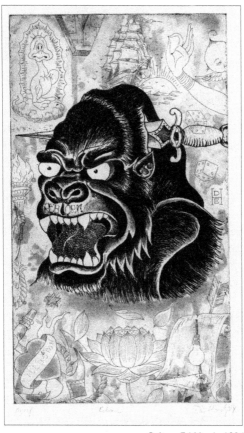

Reborn, Ed Hardy, 1994

field, because with me, tattooing was essentially about making pictures, making a mark. It was visual. Again, I think tattoo will just keep growing wider and wider and wider, to where the barriers have been knocked down; where it is a widespread social option. My stance always was: people would start making excuses why they *didn't* have one, and I'd say, "I don't care. I just want people who *want* to have a tattoo to not feel *guilty* about it, or have to put up with a lot of crap."

It's nobody's business… which is ultimately the most counter-culture thing. To be completely corny, it's about **freedom: It's my body and I can do what I want with it.** If you admire the thing, that's fine. If you don't like it, well, I'm not *asking* you for your opinion. I think it'll just keep rolling.

I can't believe it: even ten years ago I wouldn't have guessed what it would be today. Certainly 40 or 50 years ago I would never, never have bet that it would get to this level. It's *global*; it's not just pop, hipster, American, European kids.

A lot of cultures who've had tattooing in their past have *reclaimed* it, like the Pacific Island peoples, because the Samoans were the only people that kept it alive. The rest of the cultures: the

missionaries beat it out of them psychologically or physically. People stopped tattooing in Hawaii and in Tahiti, they stopped in the Marquesas—all these places. And now they're all doing it again with a vengeance. It's now enormous, enormous waves of tattooing.

My friend Mike McCabe writes a lot about tattooing. He was a tattooer but his background was as an anthropologist. He lived in China for a few years. He's met all these Chinese tattoo artists who are doing incredible work. He said most of them are extremely knowledgeable about Chinese art history, classical art history... and their linking it in is making a *whole other wave* that nobody has even covered yet. Hopefully, he's writing a book about it. But again, this is in a culture that we know is among the most repressive in modern history—yet there's this whole other thing going on, so it'll be interesting.

▌ V: I'm glad that you brought me back to earth. Counterculture only appeals to people who really want more freedom... conceptually, behaviorally, and in their lives, socially. They really have a drive to seek freedom and its meaning.

■ EH: And there is this tremendous pressure, obviously, on everybody to *not* do that. As usual, people are afraid of things they don't

understand… and if something is different, then depending on the degree of self-sufficiency or whatever they have, then boy, they *are* different. Whether they are a different sexual orientation, or have a different hairstyle, or tattoos, or whatever it is.

You also get these pathetic morons who are trying to *make everybody toe the line.* And the people who *aren't* going to, need to find other people like themselves. I was raised in this little beach town in the heart of Orange County in Southern California. The first time I came to San Francisco was the first time that I'd flown in an airplane. (Well, I'd flown once when I was two years old.) It felt like magic: *bang!* I'm up here. My friends who were already at the San Francisco Art Institute picked me up at the airport and drove straight to North Beach, right up Grant Avenue. Within four hours I was like, "Well, *this is it!*" I couldn't believe I was still in California, because California to me was John Wayne, John Birch Society repressive stuff. In Southern California I was always thinking, "How am I going to get out of this place?"

And that's freedom—that's what it's all about. We're all emissaries of that, and I think that it's all of our *duty* to be, again, *passing*

things along. If we're fortunate enough to have found a little escape hatch from the suffocation of greater society, then you want to let other people know that *they can get out, too.* Maybe not in the same way *you* did, but that's the terrific part about what you've published. You've spotted all this culture that became huge, largely because of your championing it, or your documenting it in a really beautiful, excessive, intelligent way. *Modern Primitives* just blew the lid off of it for the whole world—it was fantastic. That's what *we* have to do. **If we're given it, we have to pass it on.** That's one of the really old Asian rules of order. If you get an insight into something, just pass it along... and that's pretty exciting.

▮ V: Well I just read a quote from Malcolm X—not exactly a vintage Chinese painter. It was "Those who don't know, learn; those who know, teach." I'd never read that before—from *him*, at least.

◼ EH: That actually is a really old Chinese epigram.

▮ V: Oh, really? Maybe he was quoting.

◼ EH: I'll bet, or it's just out there in the *ether*... but it makes sense. It's important to keep the knowledge flowing and to keep the communication up. I think that's what makes it hard too,

when you need that solitude time. You need what to me is essentially *selfish therapeutic time* to work out your own personal demons and get this stuff *down*, but then you just get caught up in: "We're gonna go hang out and do this, and watch this event, and talk to these people." But I love dealing with people of all different generations. That's really crucial because that's where a lot of the "heat" for tattooing comes from. The new interest is in newer generations.

▌V: Well Ed, thanks so much for being on The Counter Culture hour. We're very lucky to have you.

■ EH: Yeah, thanks for having me. We're always in great agreement, solving a lot of the weightier problems of the world.

▌V: And we have fun too, we hope.

■ EH: Well, **you always have to have humor as part of it**, you know.

■ ▪ ■

ED HARDY 2013

■ ED HARDY: There's so much that's gone haywire with the art world, especially in the last

thirty to forty years. Dave Hickey [*Air Guitar*] thinks it's because of all the graduate programs in visual arts churning out thousands of people. Yet only three percent will continue to make art in their daily life from then on. Because... then you hit the *real world* (unless you're entitled; unless you're coming from a bunch of money).

I'm *grateful* for the fact that I came out of such a stridently blue-collar upbringing where **my mother instilled in me a good work ethic. My father worked extremely hard**—talk about compulsion and drive! And I have a tremendous amount of innate drive just through *lucky genes,* you know. My parents worked hard and that's a good thing, instead of sittin' around and wondering if you're gonna get some billion-dollar idea.

▌V: I can't fathom people who ever turn on a television and just watch it—

▊EH: But now it's a great communication medium; TV has *opened up*. I love looking at escapist stuff—it's just like reading escapist noir fiction. There are all these fantastic *extended narratives* they can get away with. You can show nearly anything—or probably anything, period—if you're on the right channels—

▌V: —on cable TV, yeah. I've read that TV is

"where it's at" now if you're a fiercely-independent filmmaker—

■ EH: Shirley Rice, my high school art teacher—she and her husband *hated* television. They wouldn't have a television in their house, and they talked against it. Of course, I was raised with Middle America *I Love Lucy* and all that. But also, *Dragnet* ... all those sinister black-and-white cop shows; I loved that stuff. I'm still completely affected by that... which ties in to the Burroughs "thing," because it's *down those dark streets*, and weird bars, and everything.

▌V: I once saw a *Twilight Zone* episode where a guy's alone on a desert-like planet and some woman shows up; then after awhile he smashes her face in, and it turns out she's a robot—

■ EH: [laughs] I loved that. And I used to read those fantasy stories. I wasn't into science fiction, like "Take us in space ships out there," but psychological writing: I found H.P. Lovecraft and all those people when I was maybe fourteen. Around that period I also got obsessed with Chicago gangsters; I had a great book on the Twenties with all that raw side of life. That stuff, and Lovecraft, and some of those scary, scary writers, were really terrific. And the *Twilight Zones.*

▌V: I read every Lovecraft story I could find, all

of William Hope Hodgson, plus Clark Ashton Smith—his house in Auburn got turned into a museum and I visited it in the early Seventies. That's another original *American* cultural contribution: the Lovecraftian School of Horror/imaginative fiction, that's perhaps not as appreciated as it should be—

■ EH: Maybe that's where Stephen King came out of. And I meet young people; some of the people who work at Tattoo City are *really* into Lovecraft. We're at a different end of the trail from a lot of the world populace, just for our age. But the things that resonated with us... and I think it kinda goes back to that Gertrude Stein quote, as convoluted as it is ["The world can accept me now, because there is, coming out of *your* generation, something they don't like. And therefore they can accept me, because I am sufficiently past in having been contemporary, so they don't have to dislike me."] but the sense I got from that was: Yes, **there are certain things that turned us on, that lit us up, that gave us courage to go forward, that whetted our appetites and our curiosity**. A lot of those seminal things that were done by people decades or maybe many hundreds of years before us, are really gaining traction now with a

lot of younger people. And the Internet culture is good about that because people can find things that way and access things.

I did an interview the other day with a woman from the *L.A. Weekly*. There's a film that's opening in L.A. next week; I'm going down for it. It's a documentary about black-and-gray tattooing that came out of the prison mentality, the Chicano thing: *Tattoo Nation;* they did a great job. I was interviewed for the film; I had kind of a seminal role in helping that kind of tattooing become more public. I was talking to this woman about the Long Beach Pike: "What was it like?" and I was trying to describe it.

I said, "This was pre-Theme Park. This was the way populist entertainment had been in America since at least the 19th century and other countries as well, where it was *scary*. You had to get up the courage to go, and it was not pleasant, cheerful, normal life; it wasn't Disney-fied."

I mean, the peep shows and the penny arcades—a lot of those had dames from the 1920s in them, and they were in these antique, elaborate brass machines—you put your penny or nickel in. And of course there was still a sideshow which always scared the sh*t out of me; I never went in it, but it was on the Pike. And

there were bars.

I told her, "Everything changed when Disneyland came in" (which I was really conversant with; I had started going there in 1956 when it opened). "But the Pike had that special thing." We were just talking about my reminiscences, and then she said, "God, I was born in '78, and I really wish *I* had been around to see this stuff." I said, "Yeah, it's a world that's now so remote, because things have changed so exponentially fast since then." There have obviously been greater changes in the world in the last thirty years (or so) than there were in the last *thousand*.

But I said, "On the other hand, when I came up to S.F. and went to school, and was getting lit up by all this counterculture stuff, all of us, I think, were looking back, and were enchanted (for lack of a better word) and inspired by things that had gone before." I was telling her about all these thrift stores that used to exist on McAllister Street. They had torn down the Western Addition; they were tearing down a lot of old Victorians, and all this old crap would end up down there for almost no money. So you could find all this cool spooky stuff to furnish your apartment with. And we were all into buying retro clothes—things that maybe they wore in

the Thirties and Forties. I thought that was a great look; I had a big fedora that I got at one of those places. It was things I saw in pictures of my grandfather.

So everyone, I think, is looking back a little bit. But it used to be a deeply different context. Things were harder to find; things were more secretive, and special—when you found it, you went, "This is really extraordinary." You'd discover this book or this record… when it wasn't all instantly available. Something has radically changed with the Internet; I don't know where it will go from here, but I'm glad I'm not going to be around long enough to see it get much different. So that's one good thing about growing older…

∎ V: Everything seems to get slicker and better marketed, every day. But it feels *too* calculated, *too* slick, too contrived; there's something about it that bothers me—

∎ EH: Yeah, it's really polluted, because it seems like there's no *genuine* … We were talking about being facile, or pretty good, at something: "Well, **I wanna do something nobody's seen before**…" Now it's like *everything's* been seen, and they're referencing back instantly to everything from the past, but…

Gordon Cook hated the whole idea of *adver-*

tising. There were some people teaching a little bit of "commercial art" at the S.F. Art Institute, although it was always primarily a fine arts school (it used to be called the California School of Fine Arts) and he hated and demonized that. He said, "These f*cking people; these ad men!" He was very influenced by McLuhan and others

Beat Museum: Ed Hardy, unknown, V. Vale

when people started waking up: "You are being *manipulated* with all this stuff."

∎ V: There were best-selling books trying to expose the effects of advertising, like Vance Pack-

ard's *The Hidden Persuaders*—

■ EH: —like when they first discovered subliminal messages flashing on the screen in the movies, getting you to buy Coke—

▌V: That was in Wilson Bryan Key's *Subliminal Seduction*.

■ EH: I remember hearing about those books, but I never read 'em. But there is a little ironic sub-set in my life story: One thing that appealed to me about tattooing: I *did* have a conceptual basis for wanting to get into tattooing, besides the fact that it would free me from working for anybody, or being the meat in the sandwich of academia with the administration above me and the doting parents below me. I thought, "I'm gonna be *free*. It's a cash business; I can get away with a lot. And I'll be down in this crazy street environment as a *participant*, but also as a somewhat distant observer (the Burroughsian example, you know), neutral (nobody knows what's really going on in his head), no need to make a statement with your dress. You just 'fit in' ('Who *was* that gray person?')."

▌V: "El hombre invisible"—

■ EH: That's it: *el hombre invisible*. But I also loved the fact that "Well, this thing cannot be commodified, because all the work you do is

gonna *die.* That's guaranteed." And I loved all the implications in the Zen sense: "You're doing it for the *here and now,* and the rite of passage."

■ V: Back then, you had to master Japanese and American tattoo techniques—

■ EH: And now I kick myself for not going in and glomming up a lot more ephemera of classic *American* tattooing, because it was just *devalued:* if designs didn't sell some place, the guys took 'em off the wall.

Now there's an enormous appreciation for what's known as "classic American tattooing." Now there's this *nouveau retro* thing; there's young, *extremely* talented young tattooers all over the world mimicking that look of what 1940s Sailortown tattooing was, or 1920s—it's astounding. But it did kind of jolt me to realizing how strong that style of art *is.* And I learned how to draw it pretty well—accurately—when I was a kid. I learned to paint really good-looking flash, and correspond with enough tattooers, and create/originate designs, and swap designs.

Now, that's all I want to publish in Hardy Marks Books: collections of classic tattoo designs and works by unknown terrific people. Some of them are totally anonymous, but a lot of them we know who they were, and they painted

phenomenal flash. It's interesting to see how this has become a global phenomenon: the style of the work, along with the fact of people getting tattooed. Because **there are more people tattooed in the world today than there ever have been in history!** It's been seized with a vengeance. It's been *reconnected* with as an option for our species—that's neat. So, of course, I *do* end up talking about tattooing all the time, no matter *what* the interview's supposed to be about! [laughs]

▌ V: I know; we've hardly talked about North Beach. Now, in the first place, the whole history of what you might call "The Middle Class Creating Art" isn't more than 200 years old—it's much shorter than people think. Sure, there have been court patrons' artists—the patronage of the rich or the Church for the house artist—back to Giotto, which was the 1200s, right?

■ EH: Yeah, absolutely, in the Western tradition that was how it worked.

▌ V: Right, I generally only think of "history" in terms of the Western tradition—

■ EH: Well, in Asia, obviously the ruling people did commission a lot of works. A lot of the great Chinese painters—they would create works for that ruling class. And thank god the Chinese

kept these records. You can read phenomenal accounts of painting theory from guys in the Sixth Century. But *okay*, go ahead, it really was just the last few hundred years that populist art emerged—

▮ V: Before then, I don't think you had a middle-class, art-creating, artist class—I'm thinking of artists like Toulouse-Lautrec or Hogarth in London—

■ EH: And William Blake, who was a visionary. He made those hand-made books. Maybe more than a "class" thing it was a "mental" class. They had to be middle-class to start, and they were people that needed to make money: **"Let's see if I can draw and get paid**." That's the riff. Hogarth did these prints and published books and illustrated things. And then there were people like Turner who were phenomenal—one of the greatest painters of all time. He was just *possessed,* and of course he had the patronage of wealthy people—he'd go stay at their houses and paint the grand fields around their houses, and all that.

But we're also talking about something like *keeping that integrity.* It wasn't like they were *tradesmen*; it wasn't like they were *artisans...* which is a distinction more *codified* in the West.

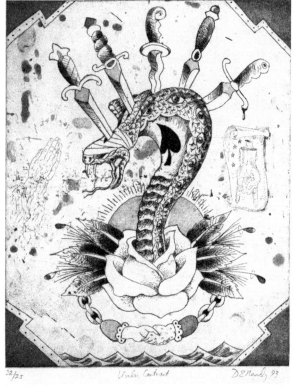

²²/₂₅ Under Contract D.E.Hardy 93

Under Contract Ed Hardy 1992

Because, again, from the Asian—certainly the Japanese—viewpoint, it's like: **you do everything to your utmost**, even if you're the guy

that pumps the gas, or you're the guy that's doing the sensitive scroll paintings—you know, you're doing it with your whole soul—

▌ V: —in the moment—

■ EH: —in the moment, and you're channeling those people from all the way back that have inspired you, whose notions have inspired you; the works that you've seen. But yeah, in the West it's the populist art that came out of—

▌ V: Montmartre is the first place I know about historically that compares to North Beach, or vice versa—

■ EH: Exactly, as a space in a great city that had a great history… of course, years older than here—

▌ V: A place where you can somehow meet people and keep getting encouraged to do your art and have the all-important occasional dialogue at a coffee shop or—

■ EH: Absolutely.

▌ V: Actually, the French *invented* the coffee shop. There wouldn't have been the French Revolution without those coffee shops—

■ EH: Yes! And, all the artists…

▌ V: So, the French invent the coffee shop… people come together—especially, the "creative" people—and, they're rebellious, too—

■ EH: Exactly.

Surf or Die, Ed Hardy, lithograph

■ V: **Rebellion is an important component of art-making—**

■ EH: Absolutely. And I think that when coffee was first introduced, it was really a volatile...

▮ V: It was a drug—

■ EH: It was a drug, and it's almost like: those people, those coffeehouses, were *hotbeds of sedition.* Because people would meet, and get all jacked up on coffee, and get inspired, and compare notes. I love that—again, when I got really serious about art history when I was sixteen, I was desperate to read about it. When I discovered Picasso, I got my first Picasso book and it was like, "Son of a bitch! *This* is the way to do it! You can just do it all across the board: *anything!* You don't have to be in one channel." And then reading the history of those guys—I want to re-read—I still have a copy of a great biography of Lautrec that I bought in '63, and I remember being so knocked out by that book, and that ambiance—of those people coming together in that city and doing this thing just out of pure *need.* And, with like-minded people nearby.

▮ V: North Beach has been good to us—

■ EH: The climate, the Bay. And again, getting back to the ocean: Gordon Cook had a completely mystical "thing" about it. He was an avid swimmer in the Bay, which I would never do—it's too cold. But he really had a feeling about some kind

of *preternatural* energy that comes from being on this little peninsula of land that's between the ocean and the Bay, and the weather changing, and the fog, and everything—this place is so *special*. It really is.

■ V: The architecture. Those Italian city planners emigrated from Genoa, a port city, and wanted to re-create Genoa here in their own mental recollections—it's beyond nostalgia.

■ EH: At the Antiquarian Book Fair, I bought a fantastic history of North Beach with photographs by a noted Italian photographer who died in the Thirties. This book is a reprint from maybe the Eighties but it was first done earlier. It has an exhaustive text about all of the family... and incredible photographs from way, way back, and how they decided to make Columbus Avenue the diagonal that it was.

And then that book, *I Am A Lover,* by Evan S. Connell and Jerry Stoll. That's one of the books that as a teenager drew me to San Francisco. You can find used copies; it's all North Beach; great black-and-white photos paired with evocative literary snippets.

■ V: There used to be a beautiful place on Green Street, Freddie Kuh's Old Spaghetti Factory, and it had—

■ EH: —that mural of everybody on the scene! [now at Cafe Divine in San Francisco]

▌V: It had all kinds of weird stuff hanging everywhere. Somehow it reminds me of the carny culture with all this stuff—

■ EH: —all jammed together. It's almost like the Caffe Sport, Antonio Latona's place, which is like a Nut Art Mecca—you talk about "Outsider Art"—

▌V: He's Sicilian, actually—

■ EH: Sicilian. Francesca is Sicilian-American; we're really partial to that food and that whole vibe; the *ferocity* of the people.

▌V: My "Surrealist/Beat" mentor was Sicilian, Philip Lamantia—

■ EH: Oh, that's right. You told me that. Because there's a particular kind of *fire* in those people. We came back here in '73; I think Latona opened the Sport in '72. We went into that place and were like, "Oh, man!" And it's still there. It's great. It's a public space, a commercial space, but it's unlike anything else you've ever seen… it's a Naive Art environment of something that *means* something to the person that did it—

▌V: But it's also part of a tradition that goes back hundreds of years: a Sicilian Naive or Folk Art tradition—

■ EH: Exactly. It resonates. It echoes down through the ages—it all has a particular place. You can take any object and trace it back and it's got a great back story. And these are the kinds of things that are not the *ersatz* crap that you spit out of a 3-D printer... It's something that's "real"—for lack of a better word.

▮ V: North Beach: there used to be a lesbian bar on Grant between Vallejo and Green (that's my memory)—

■ EH: There was the Anxious Asp [gay bar] on Union below Grant....My first trip to San Francisco, I remember a drag queen red carpet-like event going on, going into some club, and these limos pulling up, and all these stores, and the record stores, and I thought, "This is the way things should be." And the *age* of the buildings! I was raised in a town where probably the oldest buildings were from the 1920s—suddenly you're in this place that has history and architecture... it's just the *diversity*—that's an over-used word, but **it's crucial to get all those different people in one place... like-minded miscreants** or something...

▮ V: Or at least mutually supportive miscreants—

■ EH: Yeah! Exactly. Again, to find a community. Like you said, that word's over-used, but

Go With Goya, Ed Hardy

you have to find it. You have to gravitate to somewhere you can be free... I mean, they're such hackneyed buzzwords now but they're absolutely accurate. Like "freedom" first of all, to

be "who you want to be."

I want to give a plug to specific people in the Visual Arts realm that were here when I came up here. When I came to S.F.A.I. I learned about its history of all these great painters who were here before: Mark Rothko, Clyfford Still, and... I was really crazy about a lot of New York School painters, especially Franz Kline and later Willem de Kooning. This school was in California but it was connected to big movements—things that really changed American art in the Post-War Period.

The Bay Area figurative painting that was going on then when guys like Diebenkorn and David Park and Elmer Bischoff blew it open, was extremely inspirational, because it was so beautiful—such beautiful painting. Everybody reading this will know that Abstract Expressionism became the sort of company line; the brand that was lauded and became worth a whole lot of money and all that—you know, commercial value, from the Fifties on. But then *these* people went back to the figurative. De Kooning never gave up representational stuff in his painting; he realized that it was idiotic to make those distinctions—they're useless. But these people turned from doing... Diebenkorn is a great abstract painter—really lyrical—and he began introducing

extremely quotidian, everyday subjects: people sitting in a chair and looking out... nothing heroic or bombastic. And it was just all about the *paint,* and the way the thing hit you when you looked at it, and the *light*—that Bay Area light... which is a huge factor.

So I was in love with that. Diebenkorn had left here, and a bunch of those people, but JOAN BROWN was still here, and she was really... Elmer Bischoff had been her mentor; he was still alive then. And between Joan Brown and Gordon Cook—they were the primary people that really, really influenced me because **they had a completely no-bullsh*t, tough outlook on art... they were extremely intelligent, deeply read, and deep thinkers**. *And,* that whole element of being "on the street"—appreciating things that weren't part of the sanctified high culture—they appreciated the stuff that was just *everyday*... you could go and say, "Look at the light in this bar."

There used to be a guy at the San Remo bar that was there almost every night, because some of the teachers were friends and we'd go over after night class. This guy Gene was a bartender and his big joke was, he'd drop his pants: "Whoops!" tryin' to get a rise out of the girls there. Just crazy

stuff! You're in this environment, you're hanging out with these older people, but they're giving you insight into making you really *think* about your

Our Gang, Ed Hardy, lithograph

work; making you think about why you're bothering to try to *do* this art, make these things, make this stuff…

And there was this passion for music: Gordon Cook was passionate about country-and-western music and blues. Joan Brown went nuts and was crazy about the Rolling Stones; Joan was a lot closer to my age; I think she was about seven or eight years older than me. Of course, she came out of the pocket fast and had a great career—one of the first young women artists to really get a big career going in the late Fifties, 1960, 1961. I came up and started studying with her in 1963.

These people had a combination of intellectualism wrapped with a no-nonsense, everyday world sensibility and a capacity to appreciate all that great energy that comes off pop culture: surfing, music, and everything else. And it had been that way here for a long time—the way that **jazz tied in with the culture, the writers and the "spirit" of the Fifties during the Beat Era**. So it was great to be around those teachers. There were people making really interesting art; there were students doing interesting things—it was a whole mishmash.

But again, walking around these streets… I

was living on a super-minimal income; I was so fortunate to get a job at the school. My mother helped me with tuition first semester; I think tuition was $385 a semester then—this was in 1963 dollars; I don't know how much that equates to now. I had an apartment for $75 a month with two other friends from Southern California splitting the rent, right opposite Bimbo's. Then I got a job on the maintenance crew at the school; they would hire students for all the stuff they could.

So I had a job. First it was, like, cleaning the toilets; then I graduated up and I was cleaning out the cafeteria; and then eventually I *scored* and got a library job my first year-and-a-half or so there, which was terrific, being around all the books and not having to scrub the floors. But there was something so "grounding" in knowing the recent history of the area: all the clubs, the comedians that got started here; the great jazz clubs, some of which were still going then.

I liked jazz; I was crazy about, of course, Miles Davis's *Sketches of Spain,* Gerry Mulligan, Thelonious Monk and all these people. You felt you were in an *official sanctified zone* where really important things had been done, and were being done… you were convinced it was certain-

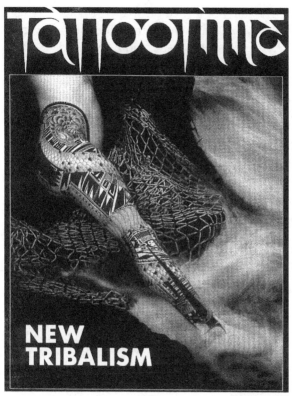

Tattootime #1

ly changing your world, and it seems like maybe it was going to change the world at large—and it did. It was terrific having that dialogue and hav-

ing teachers that would really bust your chops. And then that whole tradition of non-verbal knowledge and presentation of knowledge and transmission of knowledge… because, of course, I was hungering for everybody to give me the Five Big Secrets… I'm going to come up to the school, and they're gonna take you aside and go, "Hey, kid, THIS is what you have to do," because of course I was floundering.

You know, I'm *still* floundering! And that's the whole point: to make this stuff. And you don't know what you're really doing; you don't know if it's any good or not. I was super-frustrated by that. I was sitting in this sculpture class with Manuel Neri—a lot of guys were 3-D guys; Richard Shaw was becoming just a main ceramics guy and studied with Ron Nagle who's another great genius who scared the sh*t out of us because Ron's so volatile—he was drinking a lot in those days. So you had these people that were scary but brilliant. You just had to step up to the plate and see if you could make contact with them.

I was in Manuel Neri's class; I was doing this stuff, and I told Shaw, "He doesn't really *say* anything. He comes around and goes, 'Well, you know… yeah, that's good, y'know.' And,

'Maybe a little *here*,' or something." And Shaw said, "That's just the way it is here. A lot of the important things you just can't get by… you can't put it into *words*, man." You have to get that *vibration* (to be corny about it), or the heat that comes off being around these people; by *osmosis* you just *get* what's going on.

Pilgrim's Progress, Ed Hardy (detail)

You realize that the stance that person is taking, or attitude, or the bar they take you into, or the way they play the pool table, or the way they do something—*that* is lighting up some channel

Ed Hardy back piece on filmmaker Emiko Omori

in you; and it's almost grooming your receptors to be open to that, because it's NOT possible to get it into "25 Easy Steps."

It's like PHIL SPARROW once said about the uselessness of a tattoo correspondence course—which he had written a chapter for! *That's* how I knew about Phil when I was a little kid; he was in the catalogues of these tattoo suppliers in the Midwest. He said, "It's as useless as learning how to swim in your living room." [laughter]

It's pragmatic knowledge; knowledge that you learn by doing. That was invaluable to

me... to have these people that weren't afraid to use bad words, they weren't afraid to like crazy music. They weren't afraid to wake up hung over and not know what to do.

One of the most valuable things that I ever read was... Gordon Cook turned me on to a book called *Faulkner at Nagano*, when William Faulkner went to Japan for the Nobel Peace Prize in 1961. They wanted him to talk about his work in terms of his most successful novels—*not money*, but the ones that HE thought were the greatest successes.

And he refused to discuss that: "I can't talk about that because none of them are right!" He would only talk about them in terms of the greatest *failures*. He said, "I think *The Sound and the Fury* hit it, because I tried more in that than any of the other ones, and it just failed miserably." And I completely *understood* that—in fact, it made me feel better about being dissatisfied with the pictures I was making 'cuz they never quite come out... I mean, they'd come out *okay,* and in the heat of the moment you might think, "Man, that's a beautiful drawing," or "That's a beautiful passage I just played..." but then you look at it later and realize what's wrong with it.

I just thought that was a healthy attitude to have: to just keep chipping away at it. Look at it

really as a job of *work*—whatever the parameters are that you set out for yourself to do—and revel in that kind of—it's a *high,* really—when you get in that channel and you're making something, playing something, doing something... YOU'RE EXERCISING YOUR CRAFT.

Franz Kline said this a million times in interviews: you go into the studio and get all set up and you start painting... and when you go in you bring a lot of people with you. (I think Philip Guston quoted this, too—Guston is one of the *great* American 20th century artists; he was full of that doubt and accepted it: *dissatisfaction* with what he was doing.) But, you go in and you bring all these people with you—metaphorically; you've got history and all this stuff in your head, like "So-and-so put the yellow in *this* way." But as you work on the piece, these people begin to *leave;* you get more and more deeply absorbed. And he said, "Then, if you're fortunate, then YOU leave."

I'm a complete believer—without a lot of corny claptrap around it—that that *trance state* is why I'm doing this. Because when you're in that state, and you're doing that "thing," it might only last five minutes, or it might last several hours, but you're in a precious zone that

nothing else gives you. Surfing gives it to you in little bits. And you *want* to do that... I think that anybody that's truly involved in their work, in their chosen medium, when they're really *shining...* it's in *that zone where you don't really know what happens.*

The lectures, writings, and conversations of Philip Guston came out recently in a University of California book. It's invaluable. Guston is so eloquent. He was a tormented man with a deep, deep philosophical bent his entire life. He speaks so eloquently to *me* about what it's all about: making pictures. **He was a night painter; he would paint all night sequestered away in his studio**. The next day, after sleeping, he'd walk in and go, "Did *I* make that thing?" Because you DON'T remember exactly what went through your head.

It's one of things that I find really... disquieting. I've been filmed and videotaped several times while painting and doing stuff. I did thousands of tattoos, obviously with somebody looking on while I was doing them—but that's different, 'cuz it's a commissioned thing; it's a piece of art that you're doing to order. You're making a sandwich to their specs! But with your personal art, I know that when someone's recording me,

or even if somebody's just in the room, it changes everything a little bit... I have to consciously do it a little bit different...

■ V: HEISENBERG! Heisenberg said, "The act of observation alters that which is being observed." It's called "The Heisenberg Uncertainty Principle."

■ EH: Yes! I think it's completely true. Even if you're not super-aware of it, there's just a little different climate happening...

■ V: That, plus **the "Third Mind" idea of Burroughs—that two people talking or working together actually form a third mind**.

■ EH: Exactly! So you're accessing something, you're letting in something else, you're channeling in something else. That whole CHANNELING thing: that's a metaphor that I love, like transmitters. You want to make yourself into the most efficient *camera* that you can—because you're getting these things from somewhere else.

I love that album title *Beacon from Mars* by Kaleidoscope, who were Sixties guys. I love that notion: some ray out of space is hitting you; it's choosing *you* to, like, bore into the back of your head (or whatever)... and then *you're* transmitting this thing. It's like when you take pictures, you see the thing and you record it as a picture—

it's coming *through* you. And as you said, it's not like somebody is going, "I'm so great! I'm gonna sit down and do this thing"—YOU HAVE TO REALLY ERASE THE SELF. **You have to erase the self to get to anything really worthwhile.** Maybe nobody else will respond to it, but YOU know when it's done right! (The stench of the ego attached...)

▌ V: You mentioned that you discovered Francis Bacon in '63. Bill Brandt took a classic portrait of Bacon in '63; black-and-white—he's alone, and it looks like he's in the country, but it was actually photographed in London—the city, I mean.

■ EH: Bacon was *the* guy! Those interviews with Bacon by David Sylvester, that great English art critic—they're spectacular, talking about making art. I got a Bacon catalog from a Museum of Modern Art show in '63. It's a red cover paperback and it just SLAMMED. You see in those paintings the physicality of the paint—again, these crazy "*Ohmigod!* What are those—screaming popes?" It's the subject matter—*but it's the PAINT...* that integrity of pure paint. It's like De Kooning. It's just that this paint becomes... it just kills me when I see that stuff.

And then—of course—Bacon got really really famous, rightly so. I obsessively read prob-

ably seven biographies of him, besides his own writings, because... Of course, he was such a miscreant... and a total degenerate... but, what a brilliant guy! He designed that FANTASTIC Art Deco furniture with those Deco curves—he was a furniture designer before he began making art. Some of his furniture is featured in his paintings, where you have those curved rails and prosceniums for things to take place in. Fascinating life, though. Really, really incredible. And he had to feed his demons, of course, too—sexual demons, primarily, I guess. And drinking. [laughs]

■ V: SEX, DRUGS, AND DEATH!

■ EH: Yeah, the big three! They'll always draw a crowd! [laughs] Well, that's probably more than enough. I try to showcase a little about that "art side of me"—besides the tattoo world. Let's go eat!　■ ■ ■

Life of a Tattooer, Ed Hardy, collage (see detail at left)

ARTISTS & THE INTERNET

■ Ed Hardy: Have you been to the Jay DeFeo show at SFMOMA? Don't miss it—it's a huge retrospective. You know who she was—

▌ V: Oh yeah, "The Rose."

■ EH: I went down there yesterday to see that Bruce Conner film; it's seven minutes. The DeFeo show is pretty amazing; this was the first time there was a major retrospective. A lot of the paintings are really big, and there's a huge variety of work.

On another topic, I'd never been to Rene di Rosa's museum in Napa, and somebody drove me there recently.

▌ V: Good; that's always merciful. He didn't have any of your art, did he?

■ EH: No. One time I had a big opening and the gallery had this big dinner afterwards which he attended, but I didn't get to talk to him. He was still pretty lucid. I think he died when he was really old [ed. note: age 91, 2011], and he kind of lost it at the end.

▌ V: We don't want that happening to us.

■ EH: No, of course not.

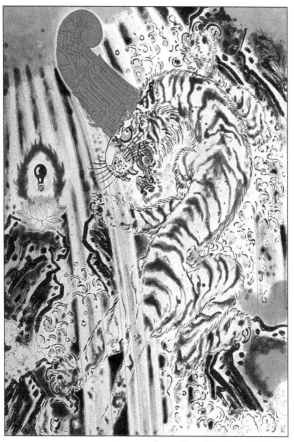

Sacred Tiger Ascending, Ed Hardy

■ V: Remember, my two role models are German. They're Leni Riefenstahl, who died at over a hundred, and the German author who was in World War I and wrote about it, Ernst Jünger— he died at over a hundred. I hear they were lucid until the end.

■ EH: If you're in good shape, that's a good goal.

■ V: I think she exercised a lot and always had much younger boyfriends. Maybe that's another secret, ha ha.

■ EH: [laughs] Regeneration? Oh, I don't know if you know Llyn Foulkes, but he's having a big retrospective in L.A. at the Hammer Museum. There's a famous picture of him in his twenties with a dead cat. His works are really disturbing, really astounding; a lot of 'em are pretty confrontational, creepy paintings that are built up layer-by-layer.

He's obsessed with Disney as *The Evil in the Universe*. His first wife was a daughter of one of those famous animation artists who started the whole era. Llyn was around this Disney scene, and he uses Mickey Mouse in some of his paintings as a symbol of everything that's wrong with the world. He's got a real rant going on. If you look online, you'll see a lot about him.

Llyn's in his mid-seventies now; he's always

lived in L.A. and he's still painting. *Finally* he's getting a huge retrospective. I'm going down for the opening with my old friend, the sculptor Richard Shaw.

My autobiography, *Wear Your Dreams,* is out.

▮ V: That's a great title, *Wear Your Dreams*.

■ EH: It was on one of my early cards. I showed Joel Selvin [co-writer] a lot of my early business cards for Realistic Tattoo and he said, "Oh man, that's a book title there."

▮ V: You're the only artist I know who made a million different business cards as an *art project*. Maybe there should be a book of those—

■ EH: **I love making new business cards all the time, with every slogan I can think of**. I always have a little one-liner or something *enigmatic*... How long are you going to be in L.A. for this new L.A. Art Book Fair?

▮ V: It's January 29th, and then I leave February 4th—my birthday! *Your* birthday already happened.

■ EH: Yeah, we're about a month apart. I think this is going to be a good year. But I always say that.

▮ V: You do? I never say that.

■ EH: I always look back at the cycles of the Asian Zodiac. I count back in increments of twelve and think back on what happened in

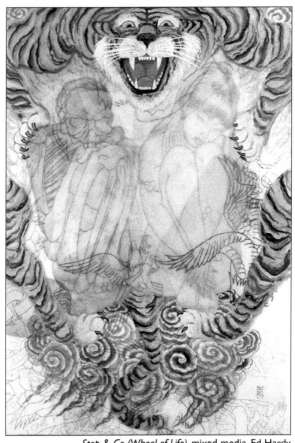

Stop & Go (Wheel of Life), mixed media, Ed Hardy

those years. This is the year of the snake and maybe it wasn't *all* great, but a lot happened. So going back: 2001, '89, '77, '65—I think that's how it works.

▌V: Well, I started publishing in '77. That was the year I finally *did* something with my life.

■ EH: God, along with this whole history of the Beat literature movement, I'm reading an incredible book on Bruce Conner, a brilliant analytical art-historical/cultural work called *Looking for Bruce Conner*. It's an MIT hardbound. It references when you were in contact with him, when he was going around with the Punk scene. He was an astounding person and also, I guess, a pain in the ass in a lot of ways. I remember you telling me you'd have to screen your calls from him.

Did you ever know Wallace Berman?

▌V: He never came into City Lights. That's how I met people, working there.

■ EH: Of course, yeah.

▌V: That's how I met Bruce Conner. I have a long interview coming out in this local, free but large newsprint magazine called *SFAQ*.

■ EH: We carry that in the shop. I advertise in that a lot. I try to support them.

▌V: Oh, good. I think it's a great, valiant enterprise.

■ EH: I read that. It's like **my reading is either escapist noir fiction or deep art history**.

▌V: Yeah, that's where I am, myself. Well, not totally. I met this guy, McKenzie Wark. I saw him give a talk at a U.C. Berkeley lecture series that Ken Goldberg curates, and he came out of Punk Rock. Then I met the guy who does UbuWeb, Ken Goldsmith. I did interviews with both of them. They're both *straddlers*. In other words, they're old enough to grow up pre-Internet, but somehow they're totally post-Internet savvy— something I'm still trying to get a handle on.

I recently read Jaron Lanier and he said that **the Internet has killed millions of middle-class jobs by putting everything online for free**: not only the creativity of photographers, musicians, writers, but lesser-known professions like recording engineers, proofreaders… Practically the entire creative middle class has been put out of existence by the Internet. Everyone I know who used to make a living is struggling.

■ EH: I know. Obviously, the Internet has wiped out a lot of print. I mean, there was never a lot of money in print. [laughter] People have no idea. Publishing is like a charity enterprise to waste the love of your life with.

■ V: Yeah, but we *leave stuff behind, and they don't.*

■ EH: That's exactly right. I don't want to leave just a whole bunch of nebulous stuff in cyberspace for people to get wrong. I want hard copy.

■ V: Lanier critiques the Internet, especially since the medium seems to dictate the message now—hey, I just coined a phrase! Everyone's reading on their iPhones because they always have them; people don't carry laptops around like they used to. I think he said that everything free on the Internet is becoming one big book; because as information gets reductionized onto the iPhone's tiny screen, it becomes sound bites and often without attribution. Your golden thoughts might appear, but no one knows who said them. So, *The Medium Dictates the Message—*

■ EH: That's right, or shapes it.

■ V: And what survives: the sound bites? Sensationalism? Sensational images; lurid content.

■ EH: That's it. It's incredible. The stuff that's out there now is just *so moronic.* It's just public entertainment for the most part. There are some intelligently done things, but *obviously there's a huge appetite for Troglodyte culture.* I mean, *jeez.*

■ V: It's just sensation. It really is.

■ EH: It is sensation. And for anyone that loves writing and literacy and all that… I think people tend to be really illiterate. Not only do they not know how to spell… it's really weird. The communication is all in sound bites.

▍V: What do they call those reductive things like "LOL"?

■ EH: Oh, there's a name for it: "LMK": let me know?

▍V: Emoticons? Acronyms?

■ EH: Pathetic. And it's hard to make any money on the Internet. I've got all this old antique tattoo imagery, and I'm trying to be really selective about which images of my personal work get out. I'll keep publishing books if we can sell enough to pay for them; you make a little bit of money and use that money to pay for a different printing. In some ways, it would be nice to have all this culture available to people, but I don't want to surrender it. It's too—I went through a lot of trouble to get this stuff.

▍V: Exactly. They don't deserve it.

■ EH: And I know the context and everything. Everything's so devalued. There's a perfect phrase for that: **flattening of culture. Everything's worth exactly the same as everything else**.

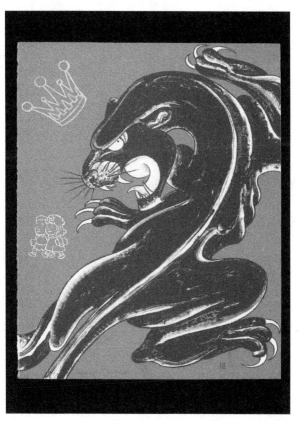

Big Top, lithograph, Ed Hardy, 1995

▌ V: And no one's grateful for it, either. The thrill is gone, for many people—I remember thousands of times finding a rare book or magazine—magazines are almost harder to find than books.

If I gave the RE/Search Top Thousand Book List, someone could probably go online and find it all in two hours, what took me a lifetime to discover. Something is wrong. [gloomy]

■ EH: Well, sometimes I do have a pretty *cheerful* outlook. I figured out that I might be manic-depressive. I get really happy sometimes, but I'm depressed for about 40% of the time. So when that goes on, I just succumb to it. I don't get upset, I just go, "Well … I didn't get that done. I didn't finish that book…" It's the only way to go for me. Why get all optimistic? If something goes wrong, you're mad. You think: *This wasn't fair.* Some guy I worked with years ago went on a rant like this and I said, "Damn, **life isn't fair. Haven't you figured that out yet?** I mean, you're in your thirties."

▌ V: [laughs]

■ EH: I always treasure people like Burroughs that totally *get it:* this is the way it is. Always skeptical, always assuming there's going to be a shadow to something. A hidden agenda.

▮ V: A hidden profit motive, or something often tied to money (or sex).

■ EH: Or psychic energy, yeah. All those great characters he invented: species of fetal people that feed off people's energy in unpleasant ways... [laughter]

▮ V: He nailed it. I'm, of course, a huge J.G. Ballard fan, too. Ballard is kind of different: a) he's heterosexual, and b) he raised three kids all by himself.

■ EH: Oh yeah? He didn't have a partner?

▮ V: She died really young. Two terrible things happened to him: those years at the concentration camp in Shanghai, three or four years in which all parents and authority figures lost their authority. He just saw appalling things. Second, losing his wife so early. I guess his kids were four, five, and seven. And they go on vacation to Spain, and all of a sudden his wife just dies on him. Then he had to raise the kids by himself. So he's very dark... but kind of funny and poetic, too.

Dig out my book of *J.G. Ballard Quotes* and look at "How I Work" or "How I Create" or the "How I Write" section.

■ ▮ ■

INDIA, DUBUFFET, MANKELL

■ V. Vale: Didn't you just go to India? I don't remember you mentioning India before—

■ Ed Hardy: I was interested in the old time art and all that, but I never wanted to go there because it's so filthy, which it is—I knew it was like that. With Francesca's involvement in the last ten years with textiles, well, India is like the "mecca" for textiles. And she met some Indian women at conferences and workshops she's gone to. So we went over as part of a tour.

■ V: Right.

■ EH: And it *is* really hard to take. The problem is that the tour had booked too many things to do! The pace was really kind of excruciating; you didn't have time to digest a place. And it *is* astounding; it's complete "heaven and hell." There's just unbelievable poverty and filth— then all this lavish, incredible historic architecture and these super-rich people.

I think the thing that's most disturbing—that no one talks about over there—is the caste system. I'm so naive politically and history-wise, except for art; I didn't know what Gandhi's "thing"

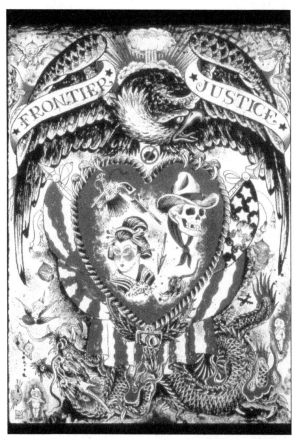

Frontier Justice, Ed Hardy

was about, which was to do away with the whole untouchables system. That system is still very strong, and there's a lot of tension.

People kept saying, "Oh, everybody gets along" and they *do!* Like in this insane traffic, there are no lanes, no signs at all, and animals are wandering on the streets while they're driving, and all the beggars, and all the crap—piles of it. I only saw one trashcan in the whole place. We saw garbage everywhere and we thought that people would get out and have fist-fights in the traffic... and I realized that *they get along.* But they probably get along and are resigned because that's their *mindset,* you know: "I'm born to sweep dust here, and I'll never do anything else." I mean, it's far worse than in England— that kind of more structural *class* stuff that exists. We liked a lot of India, but in other ways it's just... really intense.

▮ V: But I thought you saw something really beautiful, whatever that was.

■ EH: Yeah, old sites, historic places.

▮ V: They've been there forever.

■ EH: Yeah, a couple thousand years.

▮ V: You have to be sort of meditative about it because it's not verbal.

■ EH: Yeah, It's more intuitive. You have to be

"cultural." You know, I've been interested in the Buddhist philosophy and China and Japan for so many years, but I just didn't respond a lot to Indian art. I liked those Indian miniatures in a *formal* sense: "This is cool." They've got a million gods and the iconography is unbelievable— no one will be able to unravel all of it—but I just didn't have an *empathy* with it. But then, after *being there,* I'd like to go back and see less "stuff," at a better pace.

■ V: Yeah, fewer places, more concentrated.

■ EH: Yeah, more concentrated.

■ V: Wow. I was never interested in even going to India, or studying the art history of India, but in the back of my head I knew it was one of the most ancient written cultures in the world.

■ EH: It's where everything came from. This friend of mine was in town recently; he's an old India aficionado and has been there thirty times; he's a sculptor and an artist—he actually got a scholarship and went to school there and studied classical sculpture years ago. As he put it, **"Everybody—the whole species—came out of Africa and they just walked up to the Indus Valley**." India: you really get the sense it's where everything came out of; all these primary religions and...

■ V: Well, it was before China and then Japan. Japan, as I understand it, was a split off from China, like the people escaping England to find another place and they founded "America" as we know it.

■ EH: Yeah, so it was interesting, but there *is* a huge economic disparity. When we were there we were reading in one of the English language newspapers about all these billionaire guys (Bill Gates, Warren Buffett) that had a big powwow with super-wealthy Indians, because there are tons of billionaires there. There's a strata of incredibly rich people, more than anywhere else in the world. These people—

■ V: More billionaires?

■ EH: So, so, wealthy, and the philanthropy there is almost zero. And Gates and these guys were going, "How much do you need?" Maybe it's just not part of their tradition. Or maybe, as obviously smart as these guys would be to jack themselves up to that economic level, you'd think they'd have some sort of humanist empathy to *not* go, "Well, we're Brahmins and we deserve it. And the rest of the people, why should we give money to *them?*" But the disparity is just crazy. You're in places that are so lavish and then you leave this walled world of the hotel and

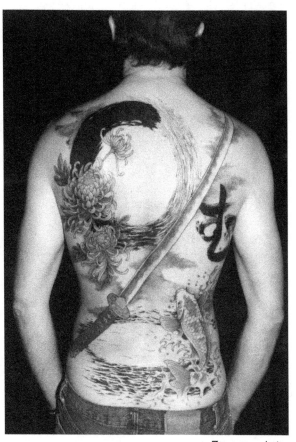

Zen tattoo design

it's just squalor with a capital "S." Unbelievable squalor—it's crazy.

■ V: I read there are a billion poor people in India, more than in sub-Saharan Africa. I'm like "Holy Cow!" I didn't think of it that way: 1.2 billion people in India.

■ EH: Right: an enormous amount of the poorest people in the world live there, and the country's not that big geographically. It's *pretty* big, but it's not the size of the US or anything. And so the crowding—when you're out of the cities, there's a lot of open countryside—but the cities are just nuts; it's crazy how crowded it is.

■ V: Yeah. Some billionaire built a twenty-seven-floor house in Mumbai.

■ EH: Yeah, I read about that. It's just crazy.

■ V: I spent some time with Brion Gysin and he talked about going to a major, super-crowded city in India where everyone was avoiding this big black lump on the street. He had to return on the same road, and then he looked more closely and this black lump turned out to be a dead human that'd been there, God knows how long, totally covered with black flies. I'm like, "Whoa—what an image!"

■ EH: Yeah, it's just crazy. Did Burroughs go there?

▮ V: No, no.

▮ EH: Ginsberg was so big on India because he was so flipped on the religious angle, the mystical angle.

▮ V: I still think Ginsberg's best poem was "Howl" and it all came out of being in the very beginning of the Beat Scene here in San Francisco on Montgomery Street, not in New York.

▮ EH: Yeah, it was all really fresh. I don't really read poetry. I don't dislike it, but I have a hard time with it. I have to *make* myself look at it. And so, I haven't read Ginsberg's other stuff, really.

▮ V: A funny question: Why do art?

▮ EH: This is my stance and I think it's right: **people should do art because they're driven to do it, because they can't NOT do it.** Not say, "Well, what can I be? This would be *cool*." Or, "This has got some good clothes to go with it"—something that's so *vacuous*, you know?

▮ V: That's why for a long time I preferred "Naive Art." Then the powers that be changed the term to "Outsider Art"—

▮ EH: Right, and it became a commodity thing... Dubuffet was really the first one *on* to that. And then Dubuffet in conjunction with some of those shrinks that ran mental institutions (the

Prinzhorn collection and some of those other places) made us realize it's phenomenal stuff. There's a great show right now at the Berkeley

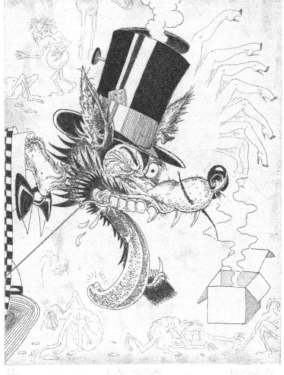

Wolffie the Preta, Ed Hardy, 1993

Art Museum called "Create" and it comes from the Creative Growth Art Center in Oakland, San Francisco's Creativity Explored, and NIAD Art Center in Richmond. Here are people who have something deeply developmentally wrong with them, yet are *compelled* to make this art. It's an incredible show. It's really big, and the work is fantastic. Don't miss it.

▌V: I remember seeing a Henry Darger show at BAM that was pretty amazing. Next month I'm going to Lausanne to see the Dubuffet Art Brut Museum.

■ EH: Oh, that's supposed to be fantastic.

▌V: I know. A friend in the early eighties went and took photos for me. It's just amazing stuff. Some of the objects on display have, I'm sure, been ripped off by so-called "real" artists.

■ EH: Oh, that's worth a trip.

▌V: Didn't *you* take an e-Book reader to India?

■ EH: Yeah, because Francesca got me one of those Kindles. I used it a tiny bit, but I ended up visiting bookstores in India. The books were super cheap—I mean, *everything* is so cheap in India.

▌V: Oh, that's good. I loved those tiny Hanuman Press books that were printed in India.

■ EH: Did I talk to you about Henning Mankell?

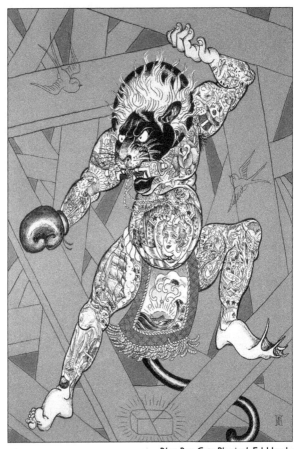

Blue Boy Gets Physical, Ed Hardy

Did I tell you I saw him talk? Later, it was broad-casted on the City Arts and Lectures public radio station. I marked it on my calendar, so we sat and listened to it, because I wanted Francesca to hear it. It might have been edited a bit. People asked him a whole lot of questions and he's brilliant about his process of writing—he's insanely smart, with great social consciousness. He was saying, "In Sweden, we pay high taxes, but at least we *get* something for it. We know that all our health care is taken care of; we know that every child can go completely through school." Because they're not spending it all on a bunch of military hardware [or surveillance]. He says that Sweden is a true democracy. It pays attention to what people want; it minds its own business… What a switch!

▌V: It's not imperialist.

■ EH: Exactly.

▌V: I know: America—the hidden imperialism behind this country's self-image. I love his book *The Man from Bejing*.

■ EH: That was fantastic! Yeah, I forgot you read that.

▌V: It's his best book. He has a new one out—

■ EH: It's the final Kurt Wallander [Swedish detective] book. He doesn't die in it, but it's like

his last...

■ V: Oh, you've already read it—

■ EH: Yeah, I read his stuff *immediately.* Some-one else I've met who's a big fan of his work said that their favorites were—they didn't even like the Wallander series—they thought that all his books on Africa were the best. I haven't read any of those.

■ V: No, I disagree; totally.

■ EH: Because I love those Wallander books. He's just this regular guy with a lot of problems.

■ V: Yes... There's nothing like hearing a per-son being interviewed or talked to, live—that's the real person. George Bush or Ronald Reagan couldn't talk without teleprompters; they had nothing in their heads.

■ EH: No.

■ V: Did you read that piece ten or fifteen years ago in *The New Yorker* written by Nicholson Baker? He wrote a horrifying article about when the main San Francisco Public Library moved to its more designer, star-chitect building—

■ EH: It blew our minds, it was completely f*cked up—

■ V: Horrifying! They hauled millions of books to the dump! Like, "What?"

■ EH: Before I read that article, I walked in to

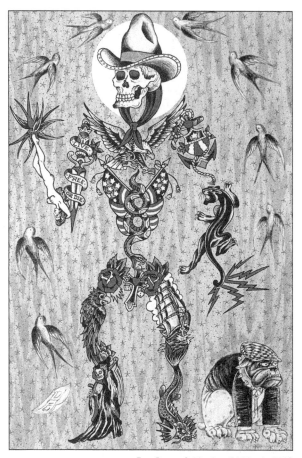

Free Range & Howboy, Ed Hardy, 2009

the new Main Library, went to the art section, and asked, "Where are all the books? Where are the stacks?" They wouldn't give me a straight answer and I thought, "What the f*ck?" It's another monument to an architect's ego. Someone must have said, "We're going to get this *so* nicely designed." There was a little sort of *token display* of some shelves of books and I thought, "This is insane!" knowing that, going through the stacks of the *old* Main Library, it was incredible, down those chambers...

■ V: There were those little dark aisles.

■ EH: That was the *real deal.*

■ ■ ■

SURREALISM, LONGEVITY

■ Ed Hardy: This Bunuel autobiography, *My Last Sigh,* is really interesting. He made a ton of films. I haven't seen *The Andalusian Dog* since I was in art school. He's obviously a really perceptive guy, at the heart of all that radical cultural movement [Surrealism].

■ V. Vale: I think he was the most subversive of

the Surrealists. He was also a bit of an Outsider. I don't approve of going to those weekly lunches with André Breton and getting hung up in that power dynamic. **Whenever people cluster in groups, hierarchies form, and people compete for the attention of the head honcho.** I think it's "bad" for you.

■ EH: Breton was running it like an army or something—f*ck that; the point is to get AWAY from those kind of Control Systems—

▮ V: Control Systems, exactly. But, it's not like it was ALL negative. There were so many visual artists, and Breton kind of *insisted* that everything have a title. If an artist couldn't think of a title, they'd all sit around and brainstorm and try to come up with one.

■ EH: [gloomily] Yeah...

▮ V: I guess that's okay. But one thing he did was: even if you were a visual artist, he'd try to get you to write some Surrealist fiction or poetry. So a lot of 'em did! It's like: if you set a goal, you can magically reach it.

■ EH: Sounds too FORCED; too forced—

▮ V: Well, I don't know. My favorite Surrealists were women: Dorothea Tanning and Leonora Carrington, and they not only did incredible visual work but also amazing, poetic Surrealist

fiction—I just love it. I'm not sure they would have done it if that idea hadn't been out there of "channeling." It's sort of **the "Everyone Can Do Everything" idea**. The "good" part of the group is: I guess you get *encouraged* more, than if you're *by yourself* all the time—

■ EH: It helps you get in the mood to DO IT. That's what people say about going on retreats and workshops. I have friends who go to places where they just "get away" and they're all in their own work environment but they'll have dinners together and stuff—people get *fellowships* to go to these places; I can see how it works. But, everybody has different work methods.

Next weekend I'm going down to Southern California to be on a panel [Aug. 24, 2013] at this Kustom Kulture II Show that Greg Escalante and Craig Stecyk are putting on. It was mainly Escalante who started *Juxtapoz* magazine with Robert Williams as a kind of "figurehead." It's the twenty-year anniversary of the *original* Laguna Beach Art Museum show which featured stuff from the Fifties and Sixties "car culture" from Big Daddy Roth, etc. Suddenly it's twenty years later and they're doing another one at the Huntington Beach Art Center that's about twelve miles up the coast from Laguna Beach in

Hawaii-inspired pin-up stencil

Orange County.

I didn't have any work in the original show, but there are a few pieces in this one that Laurie Steelink helped bring in. The "Kustom Kar" thing has spread and become such an international phenomenon—my buddy McCabe said that this "Lowbrow Art" is going on in *China* now, with Low Rider cars and all. And McCabe, who documented the Low Rider scene for the *Kustom Japan* book I published (he took the photos and everything twelve years ago) says that in South America it's a big style. And all that L.A. Cholo/Pachuko style of black-and-gray tattoos, and the style of dress that came out in the Late Forties and Fifties—that's huge now. So, it's big in South America; it's big in Japan; in China they're picking up on it—it's a really powerful kind of Alternative Culture breakthrough.

▮ V: **The idea of a "Low Rider Car" movement in China seems amazing**. So, your autobiography, *Wear Your Dreams*, is published in international editions?

■ EH: *Stern* magazine from Germany is coming over to interview me.

▮ V: *Juxtapoz* magazine has persevered for decades—

■ EH: They really had a good idea. I've heard

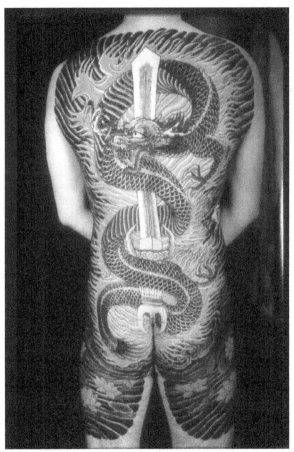

Horiyoshi II Kenryu back design

it's the biggest-selling art magazine in America.

■ V: More than *Art Forum*?

■ EH: A lot of the ads in *Art Forum* are "vanity." I mean, who does most of that stuff appeal to?

■ V: Well, collectors, gallerists—

■ EH: I think it's "snob art"... for people who are trying to pretend they're sophisticated enough to be able to afford these obscenely-expensive and vapid "works of art." [laughs] Let's face it: that's why *Juxtapoz* did so well. It's not like populist taste is *better*, but frankly, art just got so... That's my bitch about the whole art scene, the art world, the strategy and the investment principles and—it's just *snobbery*. [laughter]

There's some good stuff that gets "in," but it just seems like there's so much that's "Why bother?"—devoid of anything with real "soul" or something, you know? Did you see that Allen Ginsberg photo show at the Jewish Museum?

■ V: I was on a panel there last week.

■ EH: Oh, good. I saw a show of his *years* ago on Geary Street; he had handwritten stuff on all the photos. This coming Sunday there's a movie about Philip Guston that was done before he died, and Bill Berkson is gonna talk afterwards—that's at the Jewish Museum.

▌V: Darn, all day Sunday I'm going to the *Boing-Boing* party. Our pal David Pescovitz does a hipster online "news" site which tells you about everything hip, funny, and weird. It may be in the "Amusing Yourself to Death" department—there's so much great stuff *for free* on the Internet that you could easily waste your whole life—

■ EH: —waste your whole life. There's *too much* to access—

▌V: —and it's all *great!* Or quote "great" unquote.

■ EH: Yeah! At least to me it would be worth seeing, but you simply just can't do it. **If you're always taking in all this stuff, when are you gonna do anything on your own?** Everybody's just passively dialing things up—

▌V: And before you know it, you'll be on your deathbed wondering, "What did I do with my life?"

■ EH: "I looked at 50,000 collages—"

▌V: Or, "I looked at 500,000 images and shared 'em all with my Facebook friends." My intern finds all these funny images and shares 'em on Tumblr—

■ EH: The tattooers I know use Instagram more. They take photos and post them there from their phone and it's instantly just viral. It's a big deal.

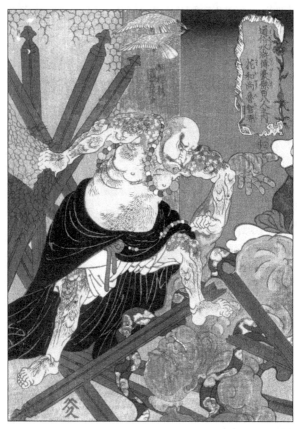

Japanese print

▮ V: Take instant photos or video and then post 'em. It's changed from being just a phone to being an immediate photo-sharing device.

▬ EH: It's just a little computer. I'm not *trying* to be a Luddite; I don't have time to a) think about things I want to think about, and b) to look into things that I *personally* think have more resonance or value. So much of the Internet is just surface stuff.

▮ V: To me, life is all about leaving stuff behind which is *tangible,* and I definitely don't trust leaving stuff behind on the Internet. There are already millions of websites that aren't there anymore; you go to the links and they're gone. But people think that once something's on the Internet, it's there forever.

So, you're on your way to China; have you been there before?

▬ EH: Just to Hong Kong, back when it was still British.

▮ V: Well, when you go to China, you can take photos of everyone you meet and post 'em; it's a memory-augmentation device. I try and take a photo every day just to help remember what I did.

▬ EH: Definitely, a *visual* will jog your memory —you don't have to stop and write it down... Where'd *you* go to college?

■ V: U.C. Berkeley. Got a B.A. in English that was completely useless. I probably told you I also got into Harvard, but when I visited the campus I was totally intimidated.

■ EH: That's what I thought when I got into Yale graduate school. I thought, "I'm gonna be so *out of my league,* in the art department in this famous, famous revered university." So I changed my life's course by saying, "I'm gonna be a tattooer."

I just read a feature in the *S.F. Chronicle* about a Chinese painter, Tyrus Wong, who's over a hundred years old; he lives in Santa Monica. He came to America around 1919. He was always an artist, and then he worked for Disney on that *Bambi* film which was one of the huge breakthrough animation films in the late thirties. There was an illustration in the paper of a forest fire that looked like abstract Chinese painting brushwork; it sounds like a fantastic exhibit. He makes kites, and there was a picture of him on a Santa Monica beach with a giant kite that his daughter helps him fly, with a detailed Chinese caterpillar-like design. He just sounded like an amazing person with an incredible life story. He came over here when there was all this anti-Chinese racism going on in California, and

is still alive. He's a pretty cool artist…

▮ V: That's our role model: longevity and—

■ EH: —staying lucid.

▮ V: Longevity and lucidity: the two "L" words—

■ EH: The Double L Ranch!

▮ V: Longevity, Lucidity, and—

■ EH: Luck!

▮ V: Boy, luck is so important. But sometimes opportunities are *in disguise*—

■ EH: You have to see it!

▮ V: That's what you did with tattooing. You saw that no one had applied high-art, universalizing consciousness to tattooing; they had all ghetto-ized it and willingly participated in an *Aesthetic Control System* which looked down on it—

■ EH: Exactly. **I love science and I love homilies that have a poetic dimension beyond what their intent is**. I've got a sign that I swiped from a cafeteria in an airport in Columbus, Ohio; the first time I went there to meet Stoney St. Clair; Alan Govenar brought me there with N.E.A. money to make that movie, *Stoney Knows How.* That's where I met Les Blank. We're at the airport getting food, and there was a laminated little sign that said, "It is not impolite to pass others in line if there is space ahead." I think it was to speed you up, if you're waiting

and there's someone ahead trying to decide which dressing to put on her salad—that's okay, you don't *have* to always just wait in line. It's *seeing that space ahead,* you know.

▌V: Yeah: Look ahead, and Burroughs always said: "Look up!" ... You know: I thought it was kinda amazing how your son Doug [age 46] came back into your life after, surely, a pretty long absence—

■ EH: Yeah. We always kept in touch, and I'd see him every so often, but he was in the Midwest. But he was in town for a convention and said, "I really miss San Francisco," and it was right around when I quit tattooing. I said, "There's an extra work booth at the shop, and if you wanna move here you can help me with all kinds of things." That worked out really well.

▌V: That is pretty amazing. Kind of the opposite of the prodigal son—

■ EH: He had a good time in the Midwest; he really liked it. Minneapolis is a pretty amazing city; it's really sophisticated, with great restaurants and art and all kinds of things.

▌V: One thing I wanted to ask you about: your dad's name was Sam, right?

■ EH: His middle name.

▌V: And he lived in Arizona for twenty years

Self-Portrait with Bonnie, etching proof, Ed Hardy, 1963

and died in 1995, right? But you didn't see him much?

■ EH: No, I'd go down there once in a while; he'd come up here once in a while; we had him over at Hawaii one time. I kept in touch with him.

■ V: And then you went down there and he said he'd gotten rid of all his photographic prints—

■ EH: Well, Francesca went down there and it turned out that my stepmother had thrown away tons of stuff. Literally she called some guy the day before Francesca got there and he took away a trunk that I'm sure had a lot of negatives— I mean, I still have a lot of his photos. That's my *almost-next* project: to do a big book of his photography, because it's astounding—the range of it. I talked to a lot of people about trying to get some kind of museum show for it; I have a list of things to do. I'm always totally booked up with projects, but we'll see. I know people would be interested in it from a variety of angles; he took so many photos of "California."

■ V: There's a huge interest in "Vernacular Photography." I just saw a big Garry Winogrand show—a lot of that is Vernacular Photography.

■ EH: Of course he was a very conscious professional photographer, as my dad was too, but it

really *was* "people on the street." There's a lot of great American photography that does that—like Walker Evans—documentary people who did astounding things. I guess it's **that appreciation of the everyday world; the Populist Aesthetic**; that immediacy of photographs.

At the SF MOMA show they played a little ten-minute movie of Winogrand; they showed him walking around, shooting people. And he held the camera like it was a book he was carrying, and he'd walk around and then bring it up and shoot somebody—completely *not* the whole "I'm taking your picture" thing. It was really illuminating to see his *method*... his work method.

Almost the entire show was made up of photographs that were printed after he was dead, off contact sheets that had never even been printed. He left something like 40,000 contact sheets. And some were marked, "Crop here" or... maybe he only wanted one image off that roll of film. That show really blew my mind. I know Sam's photography could *also* really generate a huge interest. This year I need to get connected with somebody who would really show his work and promote it.

I have projects. I'm going to China and showing

Ed Hardy guest lecture at SFAI, Nicole Archer's printmaking class

my work and talking about my own stuff; the catalog's been published. I've also been talking about doing a book of a thousand tattoos I've done. I'll work on my dad's stuff. And there's one other book I'm going to do: about this old-time tattooer that seems to be responsible for the way classic American tattoo flash looks. He was tattooing in New York in the early twentieth century and went under the name "Lew-the-Jew." He claimed his name was Lew Alberts but his real name was Al Kurzman; he lived in Brooklyn. I have enormous amounts of the drawings he did late in life when he wasn't even

tattooing anymore. He was a really seminal figure; he's talked about in Albert Parry's book, *Tattoo,* that came out in 1933, a kind of sociological study of American tattooing. He was a famous tattooer; he tattooed around New York, and just by a fluke I got this stuff... They're on the backs of letters; the shapes cut out around the design, but when you flip it over you see it's been drawn on the back of letters he received from people. Some of the letters refer to other famous old-time American tattooers; it's a book for the tattoo community. The style is real *art brut;* it's history. It's fun when you have projects! [laughs]

I have to give a talk every day of the three days I'm there in Beijing, and I have to make it *written.* I have two simultaneous translators, and I have to have it *just right.* I've been agonizing over the images I'm gonna show. It's like I did for Nicole Archer's S.F. Art Institute printmaking class, but it's not going to be nearly as long or exhausting. These will be thirty- or forty-minute talks. But it'll take up all my time preparing these.

BEATS & BIOGRAPHIES

■ EH: *God,* remember that Burroughs bio you loaned me probably a year ago or more? Last night I read 70 pages before I realized, "Oh, I *gotta* go to sleep." But it's fantastic. Hasn't Barry Miles done bios on other people? He's a British guy, right? Didn't he do one on Allen Ginsberg?

▌V: Yes. Yes. Yes.

■ EH I read that a long time ago. I bought it in Japan years ago and was really captivated by it. **Easy writing style, gets all the info, no pretense, doesn't pretty it up**… His Burroughs book is great. When did Burroughs die?

▌V: It was August 2nd. I saw him in April '97 and taped him. And then he died a few months later. It was pretty shortly after Ginsberg died. And he talks about Ginsberg where Ginsberg said, "Oh, they gave me six months to live, but I think *far less.*" And Ginsberg claimed he felt euphoric. I don't know if I'd feel euphoric if I knew I was going to die soon—

■ EH: Someone told me that when Ginsberg died, he said, "Ta-ta,"—those were his last words—

▌V: I didn't know that. Wow. I'm glad you're

reading the Burroughs book because that is like the gold standard for a biography. I haven't found anyone who can write a better bio than Barry Miles. He wrote a massive biography of Paul McCartney—and I never cared for Paul McCartney, but then I became a huge fan.

■ EH: Good biographies are priceless, right? I mean, if it's really accurate…

▌ V: Yeah, I recommend any book by Barry Miles.

■ EH: Did Doug give you a copy of that deVita book we did? **Thom DeVita's art is so eccentric and great.** It's montage incorporating some tattoo imagery. He's a totally unique person, and all these years we've tried to get people to be more interested in buying his art. His prices aren't very high, but it's so weird that a lot of the tattoo crowd don't get it. Well, some of them are relating to it now, because there are so many more alternative people in tattooing that are more sophisticated—art students, with more art-historical awareness and all that.

▌ V: Yeah. Things are changing, and I got a glimpse of how they are last night. We got a V.I.P. invite to the U.C. Berkeley Art Museum, which I have hardly ever been to in my life, because it's *over there*. I missed that great show you saw on—not Fluxus but—

■ EH: —Wallace Berman.

▌V: Yes; they had a show on his *Semina* magazine.

■ EH: The *Semina* culture show. It was great.

▌V: Anyway, there was a show last night, a huge opening featuring this local guy who graduated from the S.F. Art Institute in '91, Barry McGee. Do you know him?

■ EH: Well, I met him years ago. He and his wife were both painters, and she did graffiti, too. She died of some weird—

▌V: *She died?*

■ EH: Really young. Barry's probably in his forties. He's a huge international art star.

▌V: That's what I found out! How did that happen, and no one else in his class became one?

■ EH: It's the luck of the draw, I think.

▌V: I always wonder about things like that. And he's a nice guy—

■ EH: He's very shy and low-key. He and his wife, Margaret Kilgallen, drove down to an opening of mine at Track 16. I met them maybe 15 years ago. He does huge installations all over Europe.

▌V: Well, there were two huge books—one large hardback and a smaller, but twice as thick, hardback. They were both fifty bucks.

Seeing this large book reminded me of the

same feeling I had when I saw the first Warhol book. I thought, "Holy cow, this is not just about art, this is about *how to live*." It's a whole different lifestyle: dangerous graffiti-making. I mean, that's illegal! All that street art.

■ EH: Graffiti popped up in the Eighties or

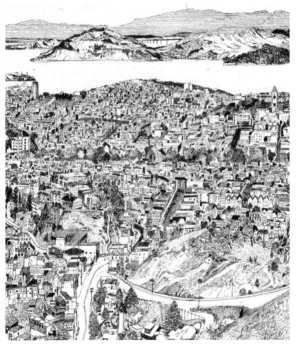

Detail from an etching of San Francisco by Ed Hardy (mirror image due to drawing/printing process)

Endless Event, etching, Ed Hardy

something. Around San Francisco, there was none. When we opened up the first Tattoo City, which was in the fall of '77, I got an airbrush and painted big Chicano-style tattoo designs, 'cuz it was a store at 25th and Mission with big display windows. We had a cactus; it was Southwest- and California—kinda Mexican-themed.

I painted in black a big woman's head with a snake in her hair, and a big black rose and an eagle. Then I signed it in L.A. gangster-writing, which I learned from Jack Rudy down there, because I was so enamored with it just as a style of calligraphy. All of that graffiti in L.A. had been going on for decades. I wrote "Tattoo City" and people would come in and go, "You guys are from L.A., huh?" There was no graffiti here in San Francisco, really, at all. But McGee and those guys like Chris Johanson got to be huge.

Speaking of that, Warhol, and those big books... We were in New York recently and there was a giant Keith Haring show at the Brooklyn Museum—early Keith Haring. I got a book there that's *that* big, literally, [gestures] with a neon pink and black cover; it's a huge compendium—a whole social document of New York in those days. You know Keith Haring's work?

▌ V: Of course. He once picked up Burroughs in a limousine in New York City.

■ EH: He went to the School of Visual Arts, and he was so on fire and so talented: "Well, you're not going to learn anymore in school," and he was living on the streets—that was the time of the Mudd Club and CBGB's and all that. But the show of his work was fantastic. He was a total populist guy, but he was really art-historically smart and read a lot of aesthetics and read philosophy.

And Burroughs was living in "the Bunker" in those days in New York. So this book was a whole social document with Kenny Scharf and those other guys who went to school with him. Kenny Scharf became super-famous in that New York scene.

▌ V: That's true. I haven't heard his name recently, though.

■ EH: Well, he's still alive and in there. I met him in L.A. a number of years ago. He's a really nice guy. I think he lives somewhere in West L.A. But there's all this detail in the book about those guys including Basquiat who O.D.ed super-young. They were all part of that movement that just exploded in New York when Haring started doing those brilliant, beautiful subway

drawings. You know, chalk.

He'd do them right in the place where the trains were going through. The show had a whole bunch of them that people had saved; they had a room with about twenty which were spectacular. They're pretty big: ten feet by three or four feet. That show was great; it captured the rebelliousness while being conscious of the

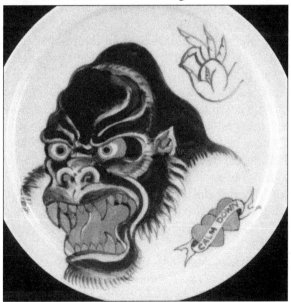

"Calm Down" Ed Hardy design on a ceramic plate

background to it.

■ V: Warhol and McGee somehow managed to bring the lifestyle into the museum. There was this amazing display of like a million used spray cans for the graffiti art. And he had a really cool coat someone had made with a dozen pockets sewn inside to hold a dozen spray cans. It showed bolt cutters so you could get into fences and clip off padlocks. They carry all this stuff. It was very illuminating. Long ago the Surrealists had said: "**No separation between art and life**." And it seems to be literally going that way even more.

It's a huge installation, really. And I looked closely at this show, 'cuz I really didn't know anything about it. I mean I'd heard his name, and I know people who've known him since before he graduated. And I looked at it and said, "You can't argue with the fact that that's a hell of a lot of work done." Thousands of hours spent. *Thousands of hours*.

■ EH: He's really prolific. He worked really hard.

■ V: There's one 360° installation of just video monitors—a lot of them. They're all showing footage that he "curated." If he didn't shoot it himself, he selected it. That's a lot of work right

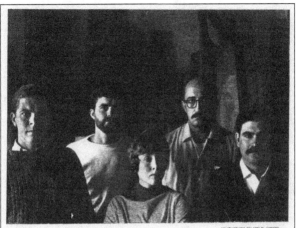

PHOTOGRAPH BY PHILIP GREENE

The Nude:
Graphics by 5 Artists

WM. H. BROWN ALVIN LIGHT JOAN BROWN GORDON COOK MANUEL NERI

Achenbach Foundation for Graphic Arts California Palace of the Legion of Honor

August 18 through September 16, 1962

1962 Exhibition Flyer

there: video editing.

Yeah, the Berkeley Art Museum was full of all these young people—I don't know where they were coming from—but there were a few people who looked like real, hardcore gangbangers with a Hispanic background from the Mission; big guys. Like, "Don't F with me." But I talked to one of them, and he was actually nice. Very soft-spoken.

■ EH: It's just a look.

▮ V: It's just a look, yeah. And the guy I talked to was with a cool girl who looked straight out of the Fifties; she had that retro image down cold.

■ EH: Yeah, that's such a huge thing now. It's a giant subculture, like the Rockabilly thing...

I was talking with my friend Paul Mullowney that I made prints with in Japan. Now he has a really cool etching press in the Mission district, on 931 Treat Street. We were talking about the gallery "thing" and the frustration involved: how a lot of the dealers will sell work and not pay the artist. He loves making prints; he's a genius printmaker himself. He used to work at Crown Point Press; he worked with John Cage and a lot of really high-end world-famous artists.

Awhile ago he worked for a big lithography company in Japan; they had a fine arts press

Trellis, etching, Ed Hardy

set-up, and he had a crew of assistants. He was fluent in Japanese; he was a very good Japanese lithographer. Anyway, Francesca and I went over and got our way paid and we stayed there for three weeks in Nara out in the country. I did this whole big suite of color etchings. It was great. So, Paul and I kept in touch, and he's got this press set-up now here in San Francisco.

I think it's really interesting that with the street "stuff," as you say, art and life are fusing. The tattoo thing is so huge now; there are shows all the time, everywhere. Like, the Beijing Tattoo Convention was super-well set up. They have it just outside the Beijing city limits, so it avoids a bunch of laws relevant to what they can and can't do in that city. I can't imagine dealing in China with the bureaucracy. But these guys put it on. They got about 3000 people a day, 'cuz there are all these insanely talented, driven, young Chinese tattooers. Ten years ago, *nobody* got tattooed in China. Nobody. It was just not done, right?

There was an article in *The New York Times* that said the Chinese army now allows people with tattoos to be in the army. Recently they decided that if they have tattoos on their hands or face, they can be in there, too. For it to get to

the point where people are getting highly visible tattoos, it's really widespread!

▌V: Yeah, I would like to go there… Locally, the shows I've seen recently were Cindy Sherman at SF MOMA and some photos by a Japanese photographer, Naoya Hatakeyama that were really, really good. I also saw Jean Paul Gaultier at the de Young—I thought that show was great.

■ EH: Yeah, it's fantastic. I love those mannequins with those animatronic faces.

▌V: I thought they were real at first.

■ EH: I know, it was really spooky. I thought they were talking. We saw the Cindy Sherman show in New York, and I really enjoyed it. It's incredible what she does.

We saw a Lee Miller show a few years ago, but just Lee Miller. It was fantastic. She's a great photographer. You know she was married to Roland Penrose for a long time, right?

▌V: That's right.

■ EH: He was a Surrealist painter, but he was connected to all those people.

▌V: Well, Valentine Penrose did some of my favorite Surrealist paintings. Wait, I'm thinking of Valentine Hugo. Valentine Penrose wrote poems; I have a book of hers, *Poems and Narrations*.

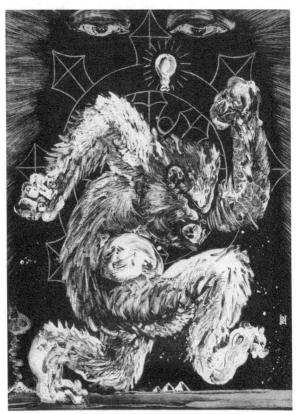

Stay Alive, etching, Ed Hardy

I thought of Francesca when I saw the Gaultier show. She knows about all these exotic fabrics and—

■ EH: Yeah, she does, and she saw that show. We actually heard him talk a little bit at the de Young. There were donors there, you know? And she's real involved with the Textile Arts Council that's a part of the museum. You know, they did a Vivienne Westwood show at the de Young.

▌V: I know. I missed it.

■ EH: Oh, you missed it? That was a good show, Vale. All that Punk stuff? It was fantastic.

▌V: At least I saw Vivienne Westwood give a talk. She was *sharp*. It was free, at the Academy of Art downtown, but you had to know about it. I saw her afterward and gave her a *Search & Destroy #10*.

■ EH: Well, we went to the de Young. There was a film about Gaultier that an ex-model of his made, and Gaultier came across as a completely real person, no attitude, no pretense. Then Francesca went to a thing for the Textile Arts Council that maybe a hundred people got into, and he was interviewed. She said he was great.

She wasn't crazy about the show because of the workmanship in the pieces. I thought they were interesting... There was a show in New York

on Alexander McQueen, who was a big fashion guy. He killed himself recently, within the last year or two. That show was unbelievable. The

Back tattoo showing a black panther

installation was unbelievable, and the garments, literally—he called them his costumes—were wild. But I enjoyed Gaultier. I'm not as critical as Francesca is because that's her realm.

▌ V: Yeah, I wouldn't be able to tell if the workmanship wasn't that good. There was so much *fabulosity* on the surface; it sure dazzled *me*. And I did see a film on him. I like Gaultier. He's just so fast.

■ EH: Yeah, he's incredible.

▌ V: And he had that really great assistant, that older woman, older than him, who was amazing. I just thought, "Wow. It's like almost—not exactly a war campaign—it's a complicated game for every year's runway show."

■ EH: I know, can you imagine that? Having to come up with these things? It's crazy. What pressure.

▌ V: In the film an American blonde girl was featured, and then they had this thing made of crocodile, or alligator, which is probably *really* hard to work with. They hand-sewed it all together, like a corset thing, but then it was too small. And only this young Asian girl could fit into it, so she got to wear it. That international modeling scene—it's weird. Some of the girls are 16 to 14, or they used to be.

■ EH: His big breakthrough, too—all I knew about him, really, was what I'd known from the beginning… was his inclusiveness of models: he wouldn't just use these super-anorexic super-beautiful supermodels. He would get people of every ethnicity and age—fat people, and he started using models with tattoos years ago when people really didn't see tattoos that much. He was just into trying to make it cross-sections of *real* people, not just this fantasy thing.

▍V: I'll be honest, learning the history of couture fashion was never my top priority.

■ EH: No, I never knew anything about it at all.

▍V: But now, I've embraced it as a branch of Surrealism. That ties it in.

■ EH: Yeah, yeah. I could never figure out—I'd see these things in the newspaper and go, "Who the heck wears these?" It's just art. Maybe they only wear it once, but they just do it.

▍V: The whole thing is Performance Art.

■ EH: It's fantastic. It's been great, Francesca's really opened my eyes to all that stuff, and I've come to appreciate it.

▍V: I wish I could have seen the Alexander McQueen show, too. I went online and saw a lot of his work. I've actually always been interested in fashion, but it was still priority-down.

■ EH: My friend Nick gave me a great biography of Man Ray—not Man Ray's autobiography, which I had years ago. But this biography of him was really fantastic. It was a fat paperback and was terrific. It gives a whole context of that movement and the people and Man Ray himself coming out of this New York, working-class, pretty poor family and reinventing himself.

▮ V: He changed his name.

■ EH: Yeah, with Kiki of Montparnasse and all that. It was really a pretty great book.

▮ V: He was pretty amazing himself at reinventing… realizing, say, with solarization, that this wasn't some throwaway accident: "Hey! This is a new technique to make art." It's like the famous story of the man who invented Post-it tape: he almost threw it away.

■ EH: You never know.

▮ V: Well, you just have to have a bigger mindset. It's so easy to be narrow.

■ EH: Yeah, it's hard to be open to recognize *what can be,* you know?

▮ V: The best things all have to do with an element of the unexpected. Or chance, too, being in there.

■ EH: Yeah, **you have to be open to recognize the breakthrough that chance makes**… 'Cuz when you're controlling too much…

Love Gets Hairy, Ed Hardy, 1993

■ V: There's a lesson there in life.

■ EH: That's right. That's right. I love reading this Burroughs book about his early formulation of *control* being the biggest thing to—

■ V: —To fight.

■ EH: That *that* is the demon, yeah.

■ V: The "control process." He invented that word for me. I would never have thought of it, but it sort of makes you way more paranoid; historically, you start doing your research differently. That's why I love mysteries, because **the best mysteries take down these really prestigious, proper-seeming people and reveal their kinky, criminal sides.**

■ EH: The main Scandinavian writer I got on was Henning Mankell. I read all of those, and then I did read Stieg Larsson: *The Girl with the Dragon Tattoo*.

■ V: There are three in that series.

■ EH: You know, I made it through them. They're not great writing; they're not Mankell, but they're gripping. The action is pretty good. I know there are tons of other people who like 'em. I think there's one mystery bookshop left in all of Manhattan; I walked in and there was a whole case, I mean *five shelves:* all Scandinavian mystery writers.

So it was because of *The Girl with the Dragon Tattoo* and Henning Mankell that broke the door for people interested in that genre and the physical setting of Scandinavia. It's such a different deal.

I read, just as complete comfort food when I was in Hawaii and laid up with the flu, I re-read two of these Raymond Chandler novels from the beginning, *The Big Sleep* and... If you haven't read those in years—they really are *poetry*. They're just real poetry because it's metaphor after metaphor of really fantastic—the writing just slams you. Of course it distracts you from the action because it's so incredibly written. The metaphors he comes up with: "A blond like a—"

▮ V: "—striking cobra."

■ EH: Yeah, exactly.

▮ V: I have to go back and revisit him. I read Dashiell Hammett pretty late in life, maybe twenty years ago. And I was surprised how **he captured the ambiance of the very beginning of people in America being introduced to ideas of socialism and communism**. That's in there, and labor rights and labor union struggles. Those labor union workers would get *killed*.

■ EH: He worked as a Pinkerton agent for a while, Dashiell Hammett.

■ V: Wow. Wasn't that a British agency?

■ EH: No, it was in the U.S., but I think they smashed unions and stuff, too. I think when Hammett lived in San Francisco, he did that for a while. He didn't write many books, though. How about the other guy in the big triumvirate of California mystery writers? He's slightly younger than those guys, and his books are based in Santa Barbara and they're really good! He was really prolific. They're all in that California coastal town setting. Tension between wealthy people and... I just can't think of his name. I'll email it to you, because when I *don't* try to remember— [ed. note: It was Ross MacDonald.]

■ V: That's the way memory works. If you don't *try* to remember, you'll remember.

■ EH: The memory deal is one of the main problems—I drive my wife crazy, and I said, "I'm really not *trying* to do this." It's like there are holes in the fabric.

■ V: I always say the most intelligent people's brains still become like Swiss cheese. When you think about it, you and I have at least twice as much data in our heads as someone even ten years younger (or whatever). So we have more to remember. There must be a limit. There become limits, I think.

■ EH: I think there are. I think things fill up, and I am happy that I had this incredible crystalline memory for remembering this arcane stuff that happened really a long time ago. But an enormous amount of stuff is probably gone forever. Even people you met last week—I'm terrible at people's names, even people I've seen a lot.

▮ V: Well, I'm glad the "Ed Hardy" brand tsunami made it possible for you to publish any book you believe in!

■ EH: That Christian Audigier: there were a lot of things wrong. But when he got in there and really had the vision, that's a very creative thing in itself, you know?

▮ V: He manufactured that Ed Hardy brand out of a database of art.

■ EH: Exactly. He had the eye to go, "This stuff would really grab people. They would like to see this," and he put it together. The first two or three years of this Ed Hardy thing, they never advertised. They *didn't spend a dime* in advertising.

He had the connections to get Madonna and the Hilton sisters, and *all these actors,* to wear this stuff. Celebrities with a capital "C," just wearing this stuff, and then you get their photographs. He was smart enough to put the

signature right up near the neck of the T-shirt, so if you take a head shot of this person, you'd go, "Oh, there's Ed Hardy." That's really smart. So that was good.

▌ V: Well, he also knew your name was really good. "Ed Hardy" just sounds so American.

■ EH: I know, it is, yeah, it's just like a classic. It's standard blue-collar.

▌ V: The Hardy Boys are part of American history and culture. I read those books as a kid.

■ EH: Yeah, and then the fact that Hardy means "strong, persistent" or whatever. It worked well.

▌ V: The best thing is that it freed you from having to work a day job—

■ EH: Right, I tattooed for 43 years. I tell people, I say, "I don't hate tattooing, but I did enough." My body's all f*cked up. It's just hard work. I'm thrilled—it was a good life, and I'm thrilled I never had to work for… Well, a couple of times I had to go work in tattoo shops when I went broke. I went broke twice in the business through my kind of hubris and obsessive belief in doing something—**it was a social crusade!** I've been self-employed ever since I came out of artists' school, and that's a pretty good run.

■ ▌ ■

AUTOBIOGRAPHY 2013

Published by Thomas Dunne Books
St. Martin's Press

EXHIBITION CATALOG
WORKS 2000-2013
BEIJING
Hardy Marks Publications

INDEX

RE/Search Catalog

CPSIA information can be obtained
at www.ICGtesting.com
Printed in the USA
LVHW080755290319
612083LV00004B/9/P